Great Modern Masters

Brancusi

General Editor: José María Faerna

Translated from the French by Alberto Curotto

CAMEO/ABRAMS

HARRY N. ABRAMS, INC., PUBLISHERS

The Universality of Brancusi's Work

The artistic career of the Romanian sculptor Constantin Brancusi followed a singular path: he moved away from an eminently traditional world and academic training to create the purest forms of the modern age, a body of work of exceptional universality. Even as a young man, Brancusi, who was born in 1876, had felt the irrepressible urge to run away. As he wrote in his later years, "The revolving earth, the blowing wind, and the drifting clouds are my real home and my only family." For Brancusi, contemplation of the

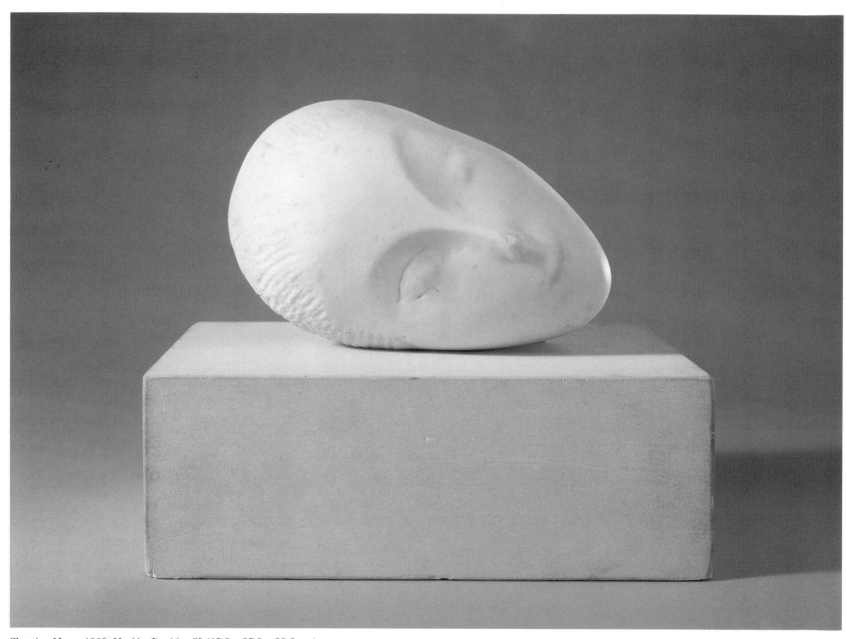

Sleeping Muse, *1909. Marble, 7 × 11 × 8" (17.8 × 27.9 × 20.3 cm).*
The Hirshhorn Museum and Sculpture Garden, Smithsonian
Institution, Gift of Joseph H. Hirshhorn (1966), Washington, D.C.
Photo: Lee Stalsworth

world always amounted to a speculation about sculpture. Even as he earned his degree from the School of Fine Arts in Bucharest, his artistic intuitions enabled him to extract the most vital qualities from his formal teachings.

"Nothing grows under the shadow of big trees"

Upon arriving in Paris in 1904, at the age of twenty-eight, Brancusi enrolled at the Ecole Nationale des Beaux-Arts. He immediately began studying the work of Auguste Rodin, whom he admired but with whom he ultimately refused to train because he believed that "nothing grows under the shadow of big trees." Brancusi opted to follow his own course. He settled in a studio

on the Rue du Montparnasse and soon became acquainted with the most outstanding figures of the contemporary art scene—such as, among others, Henri *(Le Douanier)* Rousseau, Amadeo Modigliani, and Fernand Léger. In 1907, he created *The Prayer* (adjacent plate), a female figure meant as an allegory of desolation and intended to adorn the tomb of a Romanian dignitary. This early work shows Brancusi already attempting to strip the sculpted likeness of all vestiges of academicism, striving for sheer purity of form, endowing the image with the greatest symbolic significance. Soon after that—even though he had previously aligned with the Rodinian tradition of modeling, which required the making of preliminary studies—Brancusi produced a work of near-revolutionary originality, *The Kiss*, which was carved directly from a block of limestone. In the following years, Brancusi would return to the same theme of the kiss and rework it in several other versions (plates 6–8, 44–46), perhaps the most memorable being the one he executed in 1909 as part of a tombstone for a young suicide's grave in Montparnasse Cemetery (plates 9–11).

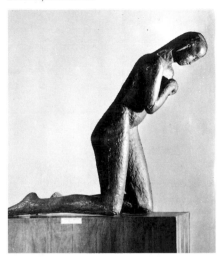

The Prayer, *1907. Bronze, height, 45¼" (115 cm). Muzeul Naţional de Artă, Bucharest*

From Paris to the Armory Show

Early on, Brancusi developed the notion that sculpture alone among the arts can reveal the underlying energies that are embedded in matter. Thus he proceeded to move away from virtually all representational details and, more importantly, he began his close investigations of essential forms. This led to a number of intense meditations on the organic shape of the egg, first discernible in the 1909 marble *Sleeping Muse* (opposite plate) and later found in many other works, such as the 1911 marble *Prometheus* (adjacent plate), the 1913 wood-carved *Head of a Child* (adjacent plate), the 1915 marble *The Newborn I* (plate 22), the 1916 marble *Sculpture for the Blind* (see page 6), and the 1924 polished bronze *Beginning of the World* (plate 29), as well as the many versions of the bust of *Mademoiselle Pogany* that he produced between 1913 and 1933 (plates 25–27). Brancusi's earliest works consistently commanded such attention that, in 1913, he was invited to participate in the first important exhibition of modern art ever held in the United States, the celebrated Armory Show in New York. Brancusi's work received such recognition that the following year he earned his first solo exhibition at the Gallery of the Photo-Secession in New York. Additional shows were held in 1916, 1926, and 1933 in New York. In Paris, in 1920, *Princess X* (plate 28) was temporarily withdrawn from the Salon des Indépendants due to the sculpture's alleged obscenity and supposed phallic shape. The artist emphatically denied the association, claiming instead to have created an ideal feminine form.

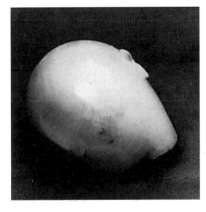

Prometheus, *1911. Marble, 5 × 7" (12.7 × 17.7 cm). Philadelphia Museum of Art. The Louise and Walter Arensberg Collection*

Wood Carving

After 1914—while continuing to work with marble and to cast bronzes, which enabled him to obtain highly polished surfaces—Brancusi often turned to working with wood. He exploited its rough texture and created squarely hewn works of exceptional strength and power, such as his 1914 *Caryatid* (see page 6), or *The Prodigal Son* and *Chimera* (plate 34), both from 1915. Later, after World War I, Brancusi's wood sculptures gained a more polished quality, as witnessed by *Adam and Eve*, 1921 (plate 35), *Socrates*, 1922 (plate 36), *Torso of a Young Man I*, 1922 (plate 30), *Torso of a Young Man II*, 1923, and *The Chief*, 1925. While a certain fierce expressiveness typical of so-called primitive art may indeed exude from these works, it is always kept in check by the artist's staunch pursuit of balance and structure. These qualities were already quite apparent in several remarkably elaborate bases, as well as in the *Column with Two Elements*, 1916.

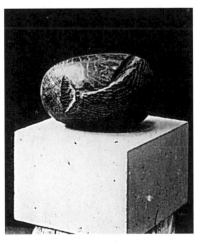

Head of a Child, *1913. Oak, 6¼ × 9⅞ × 6¾" (16 × 25 × 17 cm). Musée National d'Art Moderne, Centre Georges Pompidou, Paris*

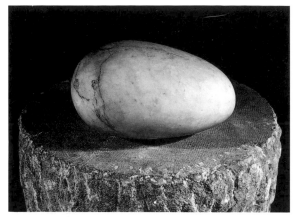

Sculpture for the Blind, *1925. Alabaster, 6⅞ × 12¾ × 9½" (17.5 × 32.3 × 24 cm). Base: plaster, 10¼" (26 cm) high × 20⅞" (53 cm) diameter. Musée National d'Art Moderne, Atelier Brancusi, Centre Georges Pompidou, Paris*

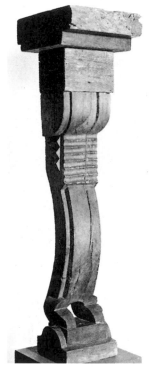

Caryatid, *1914 and 1926. Aged oak, 65⅝ × 17" (166.7 × 43.2 cm). Fogg Art Museum, Harvard University Art Museums, Cambridge*

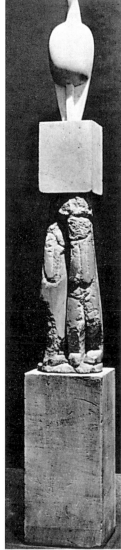

Maiastra, *1910–12. White marble, 22" (56 cm) high × 23" (60.3 cm) max. circumference. Three-part limestone base:* Caryatids *(1908), center. Overall height, 70" (177.8 cm). The Museum of Modern Art, New York. Katherine S. Dreier Bequest*

Base into Column

Like no other artist before him, Brancusi viewed the sculpture and its base—the element that, by isolating the sculpture, defines it—as an inseparable whole (see the illustrations on this page). Drawing energy from the earth, Brancusi's volumetric bases emerge from the ground and reach as high as possible, striving to attain the heavens. The fundamental idea of the *Endless Column* first formed in Brancusi's mind in 1918. He incessantly recalculated its proportions, and in 1920 he erected a column comprising nine elements carved out of aged oak in photographer Edward Steichen's garden at Voulangis, near Paris. That column bears a distinct resemblance to smaller ones that he went on to sculpt in 1925 and 1928. Even later he executed a version in plaster, but the most impressive of these works is undoubtedly the column that, since 1938, has stood as a symbol of immortality in the war memorial complex of Tîrgu Jiu (plates 48–50) in Romania.

At Work on the Impasse Ronsin

Brancusi had settled in one of several artists' studios on the Impasse Ronsin in 1916. In 1928, after a storm had wreaked havoc in his workshop, the sculptor moved to a new studio on the same dead-end street. Increasingly, his studio became the very locus of his aesthetic speculations, enabling him to fully work out the relations between his various sculptures. Everything in Brancusi's studio—an immense, white, and cheerful space—was subjected to his close attention and, with the aid of his camera, the artist set out to document from different perspectives his conception of the sculptures' spatial presence. Without being austere, but radiating all the same an atmosphere of solemn simplicity, Brancusi's studio conveyed to its visitors—for example, Marcel Duchamp, Pablo Picasso, Henri-Pierre Roché—a definite sense of the solitary grandeur of the sculptor's aesthetic investigations.

Brancusi's oeuvre developed gradually, frequently building on the same few themes that were variously treated over a long succession of sculptures. He repeatedly returned to the same shapes, putting them through a process of simplification and refinement that would ultimately cause them to coalesce into one archetypal form. The most telling example of this process is *Bird in Space* (see plates 15, 16), whose original incarnation was *Maiastra*, 1910–12 (see plate 17), a mythical bird of Romanian folklore. The radical modernity of *Bird in Space* was such that the sculpture became the center of a sensational lawsuit brought by the sculptor against the United States Customs Office—eventually won by Brancusi in 1928. U.S. Customs had challenged the artistic nature of the work, classified it as an industrial object, and consequently tried to levy a corresponding tax. The same theme of the bird was repeatedly rendered by the artist in increasingly polished surfaces.

The End of a Myth

Brancusi's quest was consistently aimed toward achieving a self-contained formal purity: the perfect essence, stripped of all attributes, proceeding directly from the physical world. The artist followed this course with unswerving enthusiasm and boundless dedication from the very beginning of his career through the great retrospective exhibition that was held in 1955 at the Solomon R. Guggenheim Museum in New York. Contrary to the mythology surrounding Brancusi, he was not the mythically intuitive but naïve and uncouth peasant that some had imagined him to be, even during his lifetime. Upon his death in 1957, Brancusi's studio—reconstructed today at the Musée National d'Art Moderne, Centre Georges Pompidou, in Paris—entered the history of art as an incomparable sculptural ensemble in its own right.

Brancusi's Universe

Of all the outstanding innovators of modern sculpture, Constantin Brancusi has certainly been one of the two or three most important. While Rodin's work, for example, is characterized by its vehement emotional exuberance, Brancusi's is the product of the artist's extremely solemn notion of plasticity, a conception both architecturally rigorous and absolutely clear. Breaking with the tradition of using the motif to create art from life, Brancusi's oeuvre signaled an entirely unique perspective on sculpture.

The Essence of Matter

Brancusi's works—from *The Kiss* (1907) to *Bird in Space* (1940–45) and *Grand Coq* (1949–54), by way of his 1924 *Beginning of the World* (plate 29)— bear witness to their author's extraordinary mission, namely his quest for the absolute and the immutable eternal. Acting as a kind of shorthand for the messages buried deep within them, Brancusi's sculptures present the viewer with smooth, bare surfaces, increasingly polished to the point of mirroring a spiritual transparency. The bare simplicity of the external forms and their rigorous volumes provide stark evidence of Brancusi's ability to reclaim the timeless and primordial essence of the plastic arts.

"Reality," Brancusi once said, "resides not in the external form of things but in their innermost essence. This fact entails the impossibility to express anything real while lingering on the surface of things." Thus the artist justified the very foundation of his aesthetics, namely his need to move beyond the object's naturalistic aspect. Indeed, his lifelong quest for an essential, unadulterated form reflects his ambition to capture not a mere facsimile of reality but a spark of the very spirit that animates it.

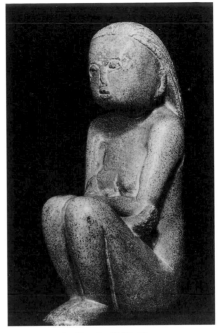

Wisdom of the Earth, *1908. Stone, 19⅞ × 6½ × 9⅝" (50.5 × 16.5 × 24.5 cm). Muzeul Naţional de Artă, Bucharest*

An Essential Simplicity

Brancusi always remained true to his intuition of the essential simplicity of pure forms (see *Little Bird II*, adjacent plate). In 1912, the sculptor visited the Paris Aviation Show in the company of his friends Marcel Duchamp and Fernand Léger. Duchamp, having rested his gaze on an aircraft propeller, is purported to have said, "That is a sculpture! From this moment on, sculpture must strive to be nothing less than that." Duchamp, diverting the propeller from its intended function, could have turned it into one of his celebrated and controversial readymades, whereby he conferred the status of art on whatever insignificant object he elected. On the other hand, for Brancusi, the smooth, soaring form of the propeller might well have evoked the very essence of flight, a conception not unlike the underlying idea of *Bird in Space* (plates 15, 16). Between 1923 and 1945, Brancusi produced some fifteen versions of *Bird in Space*—in white marble, colored marble, and polished bronze—all conforming to one "eternal archetype of transient forms."

Forms and Ideas

Moreover, Brancusi was striving not so much to represent a bird as to give shape to the very act of flying, to materialize, that is, a dynamic impression by endowing it with an essential form. He desired to create a symbol of the astonishing ability—common to birds but alien to humans—to take off from the ground and glide into the skies.

To be sure, Brancusi never produced an abstract work of art: even when its forms are refined to the highest degree, his sculpture retains a strong appeal to ideas. As the object loses its materiality, it is transformed into pure energy.

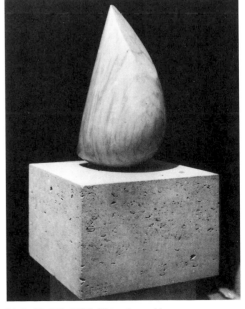

Little Bird II, *1929. Veined marble, 25¼ × 15 × 14⅛" (64 × 38 × 36 cm). Musée National d'Art Moderne, Atelier Brancusi, Centre Georges Pompidou, Paris*

Biographical Outline

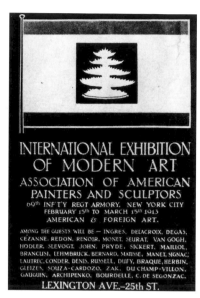

Poster of the Armory Show exhibition, held in New York in 1913

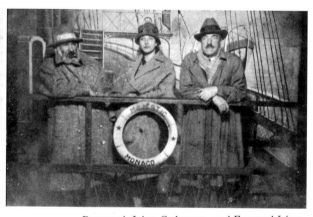

Brancusi, Irina Codreanu, and Fernand Léger at an amusement park in 1926

Brancusi installing an Endless Column *in the garden of photographer Edward Steichen at Voulangis, near Paris*

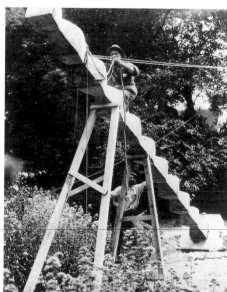

1876 Constantin Brancusi was born, on February 19, in Peştişani-Gorj, in the southern Romanian province of Oltenia.

1883–87 Attends primary school first in Peştişani and later in the village of Brădiceni. Father dies in 1885.

1887 Having run away twice before, he leaves home for good and travels around the country, taking whatever small jobs are available—waiting tables, running errands, making deliveries. Has no contact with his family back home for six years.

1894 Enters the School of Arts and Crafts in Craiova.

1897 Spends the summer holidays in Vienna, where he works with a cabinetmaker.

1898 Graduates with honors in sculpture from the School of Arts and Crafts. Enrolls at the National School of Fine Arts in Bucharest, where he studies academic sculpture until 1902. Produces his first works. Washes dishes in a café to earn his living.

1902
Receives degree in Fine Arts. Serves in the military from April to December.

1903 Exhibits his 1901 *Écorché*, an anatomical figure study, and works on the bust of *General Dr. Carol Davila* for the local military hospital.

1904 Travels to Paris, supposedly walking most of the way. Works again as a dishwasher.

1905 Enrolls at the Ecole Nationale des Beaux-Arts in Paris.

1906 Exhibits a bust for the first time in the Salon of the Société Nationale des Beaux-Arts. For the following four years, he will continue to show his work there, as well as at the Salon d'Automne. Auguste Rodin heads the Salon d'Automne jury in 1906 and sees Brancusi's work.

1907 Drops out of the Ecole Nationale des Beaux-Arts. Meets Rodin in Meudon and works in his studio as an assistant from March 24 to April 27. Meets photographer Edward Steichen at Rodin's studio. Leaves to find his own way as an artist.

1908–9 Becomes friends with Henri *(Le Douanier)* Rousseau, Fernand Léger, and Amadeo Modigliani, who, under Brancusi's influence, will take up sculpture.

1909–10 Executes *Sleeping Muse*. Meets a young Hungarian art student, Margit Pogany, who becomes the inspiration for his *Mademoiselle Pogany*. Death of Rousseau, on whose tombstone Brancusi and Manuel Ortiz de Zárate engrave some verses from a poem by Guillaume Apollinaire. Receives a commission to create a commemorative tombstone, *The Kiss* (plates 9, 10, 11), in Montparnasse Cemetery, Paris.

1910–12 Exhibits at the Salon des Indépendants. Executes *Maiastra*, earliest embodiment of *Bird in Space*. Steichen introduces him to photographer Alfred Stieglitz in 1911.

1912 Steichen introduces him to the American collector Mrs. Eugene Meyer.

1913 Executes *Mademoiselle Pogany I*. Exhibits five sculptures at the Armory Show in New York, the first important exhibition of modern art in the United States. *Maiastra* is installed in the garden of Steichen's home in Voulangis, near Paris. Brancusi also shows at the Salon des Indépendants and the Allied Artists Exhibition in London. Meets the sculptor Henri Gaudier-Brzeska.

1914 Undertakes a series of wood sculptures. First one-man show, with eight works, at the Gallery of the Photo-Secession, run by Stieglitz in New York. U.S. Customs questions the legitimacy of Brancusi's sculptures as works of art. American lawyer John Quinn, Brancusi's chief collector, purchases his first pieces. Friendships with Marcel Duchamp and Henri-Pierre Roché.

1916 Brancusi takes a new studio at 8, Impasse Ronsin. Second one-man show, with six works, at the Modern Gallery in New York. Walter Arensberg purchases his first Brancusi.

1918 Breaks a leg; unable to sculpt, he takes up drawing and painting.

1919 Death of his mother. Meets American collector Katherine S. Dreier through Duchamp. Executes *Mademoiselle Pogany II*.

1920 The 1916 *Princess X*, dubbed a "phallic obscenity," creates a scandal at the Salon des Indépendants. Associates with Tristan Tzara and Francis Picabia. Erects an *Endless Column* in Steichen's garden at Voulangis. Nearly thirty feet tall, it is cut from one of the garden trees. *Little French Girl* (plate 33) is shown at Dreier and Duchamp's first exhibition of the Société Anonyme, Inc.

1921 The avant-garde periodical *The Little Review* publishes twenty-four of Brancusi's photographs of his work along with an essay by the poet Ezra Pound, which constitutes the first important study of Brancusi's oeuvre. Associates with Man Ray and consults with him on

photography. Brancusi takes an increasing number of photographs of his own sculptures and studio.

1922 Travels to Corsica with Jean Cocteau's protégé Raymond Radiguet and, later, to Romania with Eileen Lane. In Marseilles, on the way home to Paris, he spots the young African woman who inspires his *White Negress I* (plate 31).

1923 Executes first version of *Grand Coq*.

1924 Drawings by Brancusi and Pablo Picasso appear on the program of the "Bal Banal" (Banal Ball). John Quinn dies. His estate includes thirty-four works by Brancusi. Irina Codreanu, a close Romanian friend, begins an apprenticeship with Brancusi (1924–28).

1925 The review *This Quarter* publishes forty-one photographs and a tale, "Histoire de brigands," by Brancusi. First publication of Jacques Bacot's *Le Poète tibétain Milarépa* (The Tibetan Poet Milarepa), one of the sculptor's favorite books: he would often compare himself to the eleventh-century poet and mystic. Meets photographer André Kertész.

1926 First trip to the United States (January–March), to attend his third solo exhibition, with eight sculptures, at the Wildenstein Galleries in New York. He returns in September for a fourth one-man show, at the Brummer Gallery. Brancusi visits Central Park and states that he would like to install an *Endless Column* there.

1927 The review *De Stijl* publishes "Constantin Brancusi," an article by Theo van Doesburg. Isamu Noguchi arranges to meet Brancusi and works as his assistant for several months.

1927–28 Begins legal proceedings against the United States Customs Office concerning the status of *Bird in Space* as a work of art. Brancusi eventually wins.

1928 Moves into a new studio at 11, Impasse Ronsin. Ezra Pound introduces him to James Joyce.

1929 James Joyce sits for several portrait drawings. Brancusi takes part in the exhibition *Abstract Art and Surrealist Painting and Sculpture* at the Kunsthaus in Zurich. Pablo Picasso visits his studio.

1931 Executes *Mademoiselle Pogany III*. Awarded the Order of Cultural Merit for the Plastic Arts by King Carol II of Romania.

1933 Second exhibition at the Brummer Gallery in New York, with fifty-seven works, organized by Marcel Duchamp. Introduction by Roger Vitrac,

with a page of aphorisms by the sculptor himself.

1935 Receives commission to create a monument at Tîrgu Jiu, Romania, commemorating the local heroes who died in World War I.

1936 Six Brancusis are included in the Museum of Modern Art's *Cubism and Abstract Art.*

1937 Visits Romania to supervise the installation of *Table of Silence*, *Gate of the Kiss*, and *Endless Column*, at Tîrgu Jiu. Completed in 1938.

1938 Travels to India to work on the *Temple of Deliverance*, commissioned by Maharajah Holkar of Indore. The project falls through and Brancusi returns to Europe by way of Egypt.

1939 Final visit to the United States to attend the exhibition *Art in Our Time* at the Museum of Modern Art, which includes two of his sculptures.

1940–44 Lives in seclusion in Paris during the war. Peggy Guggenheim visits the studio and buys a *Bird in Space* (plate 16).

1946 France's national museum purchases two works by Brancusi.

1947 Alexandre Istrati and Natalia Dumitresco, young Romanian artists newly arrived in Paris, begin working as Brancusi's assistants.

1950 The Louise and Walter Arensberg Collection, including eighteen sculptures by Brancusi, is donated to the Philadelphia Museum of Art.

1952 Brancusi becomes a French citizen.

1953–54 Louise and Walter Arensberg die within months of each other. Completes his last work, *Grand Coq*, in 1954.

1955–56
First Brancusi retrospective exhibition is held at the Solomon R. Guggenheim Museum, New York, and later travels to the Philadelphia Museum of Art.

1956 Brancusi directs that after his death, his studio is to be bequeathed to the French state for the Musée National d'Art Moderne. He appoints the artists Alexandre Istrati and Natalia Dumitresco as his universal legatees.

1957 Brancusi dies in Paris on March 16. His body is buried in Montparnasse Cemetery, Paris.

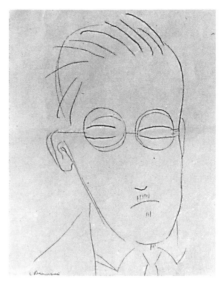

Portrait of James Joyce, *1929*

A study for the Temple of Deliverance, *undated. Drawing, 10⅞ × 16½″ (27.5 × 42 cm)*

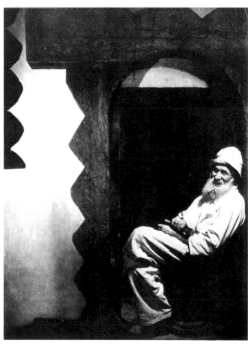

Brancusi in front of a wood "gate" sculpture in 1955

Beyond the Limits of Modeling

Brancusi liked to say that his own life was "a succession of miracles." His career, however, had begun with a prolonged period of training. His copies of classical art—such as *Vitellius*, 1898 (plate 2), and *Laocoön*, 1900—his studies of anatomy—like the *Écorché*, 1901 (see plate 52), or the *Anatomy Study*, 1902 (plate 3)—and his first portraits—that of the *General Dr. Carol Davila*, 1903 (plate 1), for instance—are proof that, while still in Romania, the sculptor did explore a range of academic possibilities. Clearly he may have resented the limits imposed by traditional sculpture, which, having lost its primordial expressive power, had deteriorated into merely formulaic activity.

Upon his arrival in Paris, the artist attended the workshop of sculptor Antonin Mercié, a strict academician. At the same time, the young Brancusi was aware of Rodin's achievement, namely his restoration of the human body as "the measure, the very module upon which the statue is constructed." In spite of that, Brancusi was always relentlessly harsh in his condemnation of grandiloquence in sculpture.

The works that he exhibited at the "Salon de la Société Nationale des Beaux-Arts" in 1907—namely, the bronze *Portrait of Nicolae C. Dărăscu* (plate 4), the plaster casts *Torment I* and *Head of a Child*, and the preliminary study for *Head of a Child*—were already endowed with a new sensibility. Brancusi's heads of children—strongly reminiscent of the subtle and refined wax sculptures by the Italian Medardo Rosso (1858–1928)—display the brilliant virtuosity against which Rodin had cautioned the young artist: "There, you see, one shouldn't go so fast." Brancusi eventually did abandon the modeling technique and oriented his interest toward direct carving, a considerably less rapid method of execution.

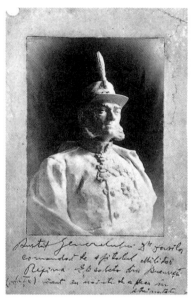

1 General Dr. Carol Davila, *1903.*
Photograph by Brancusi

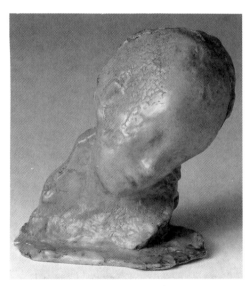

Medardo Rosso. Sick Child (Dying Child), *1889.*
Wax on plaster, height 10⅛″ (25.7 cm). Galleria
d'Arte Moderna, Milan

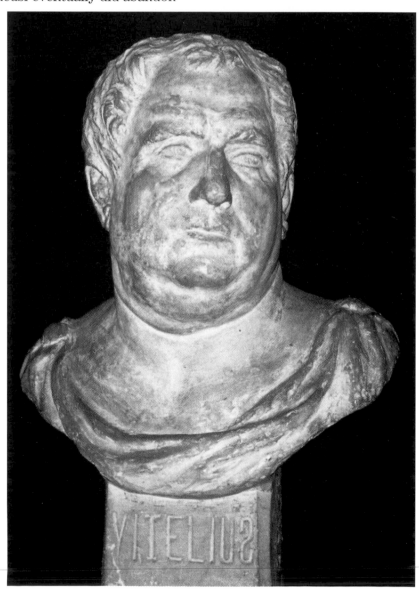

2 Vitellius, *1898*

10

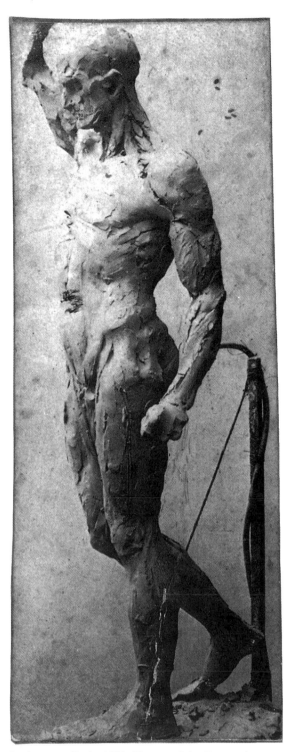

3 Anatomy Study, *1902. Photograph by Brancusi*

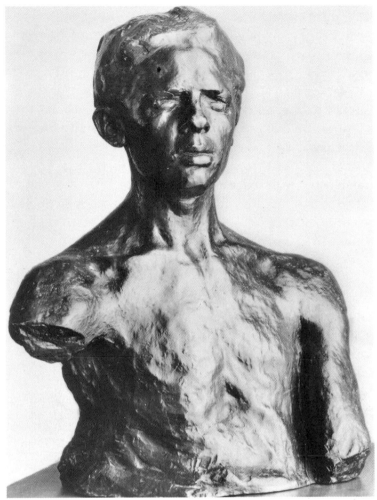

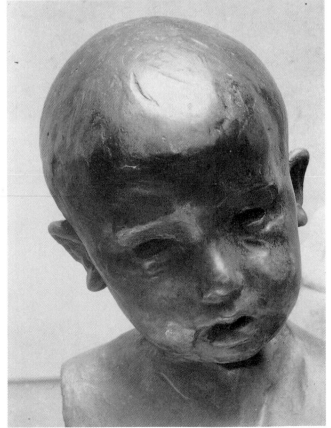

5 The Child, *1906. Photograph by Brancusi*

The Kiss

The first *Kiss* (plates 6, 7, 8) that Brancusi carved directly into stone dates from 1907. Its severity contrasts with Rodin's sensuous and tormented handling of the same theme. Brancusi suggests the presence between the two lovers of an intimacy that appears to be far stronger than fierce physical desire. As an expression of love, this early *Kiss* is both more concentrated and more nuanced than Rodin's. Brancusi's most widely known *Kiss* is that of 1909 (plates 9, 10, 11), which stands in Montparnasse Cemetery on the gravestone of a young Russian woman who committed suicide following an unhappy affair. "The task was to represent a united couple as a funerary monument. What I created doesn't look like that couple at all: it resembles every single couple that has ever loved and embraced on earth."

This strikingly stark sculpture represents a man and a woman tightly holding each other as if they were a single compact unit. Its symmetrical composition as well as the simplicity and purity of its lines are extremely original, quite unlike the prevailing conventions of contemporary funerary art. The theme of the kiss would reappear: notably between 1933 and 1937 in the drawings that Brancusi sketched as plans for the *Temple of Deliverance* (plate 13); then, in 1938, in the *Gate of the Kiss* (plates 44, 45, 46), one of the elements of the Tîrgu Jiu memorial complex; and eventually in the *Boundary Marker* (plate 12) of 1945.

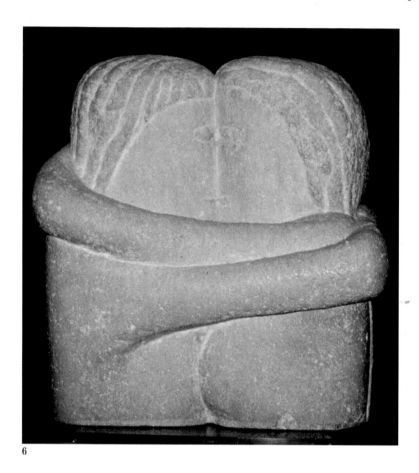

6

6, 7, 8 The Kiss, *1907*

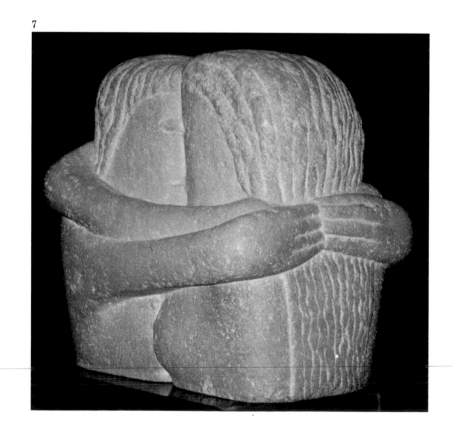

7

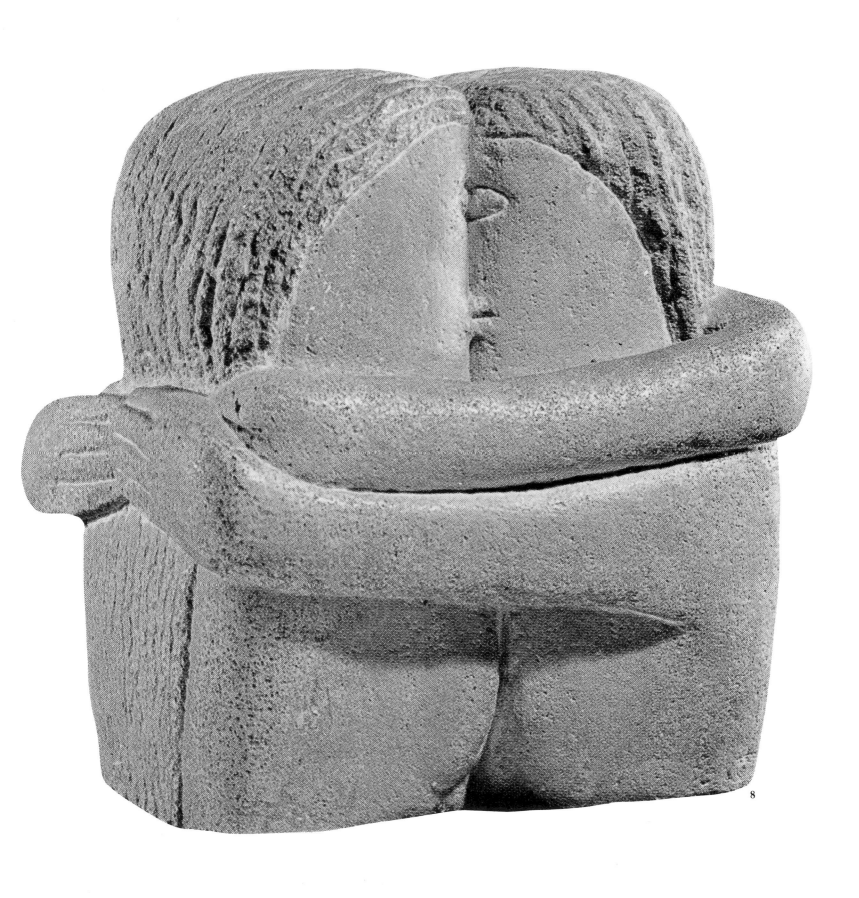

8

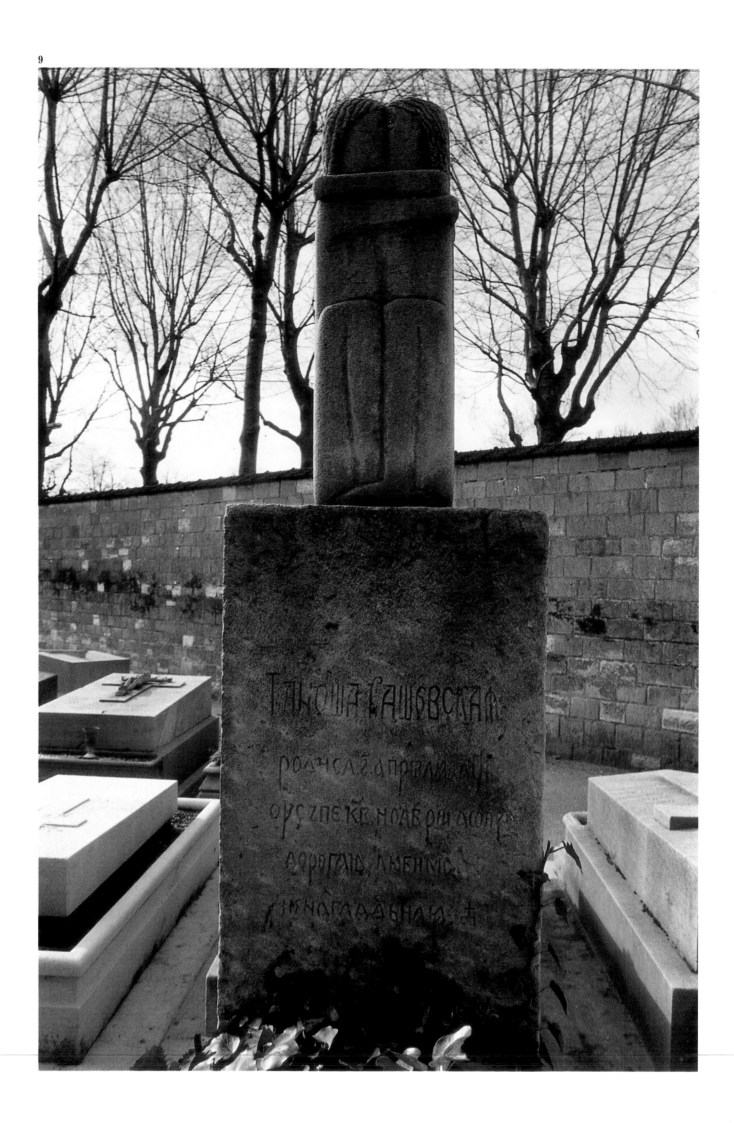

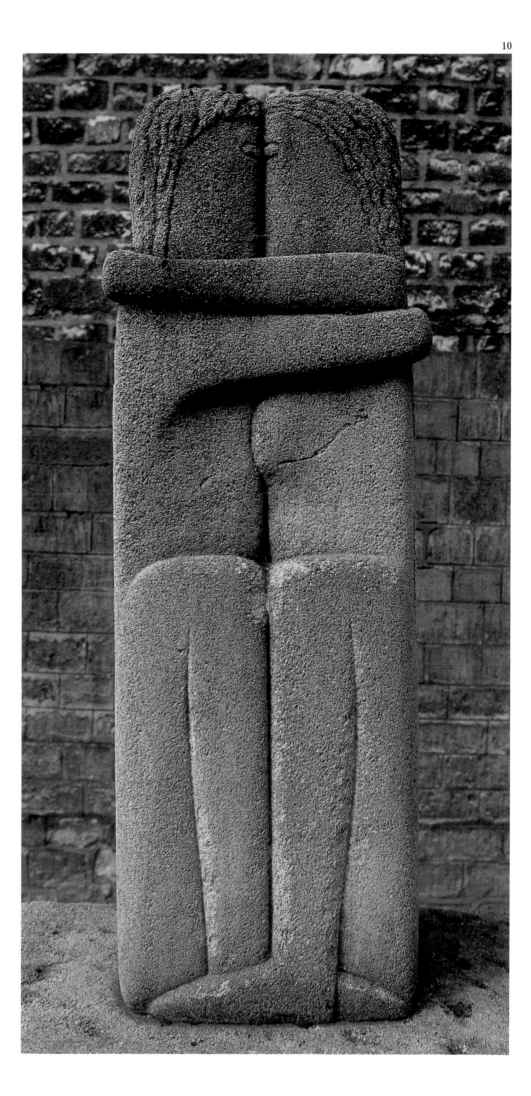

9, 10, 11 The Kiss, *1909*

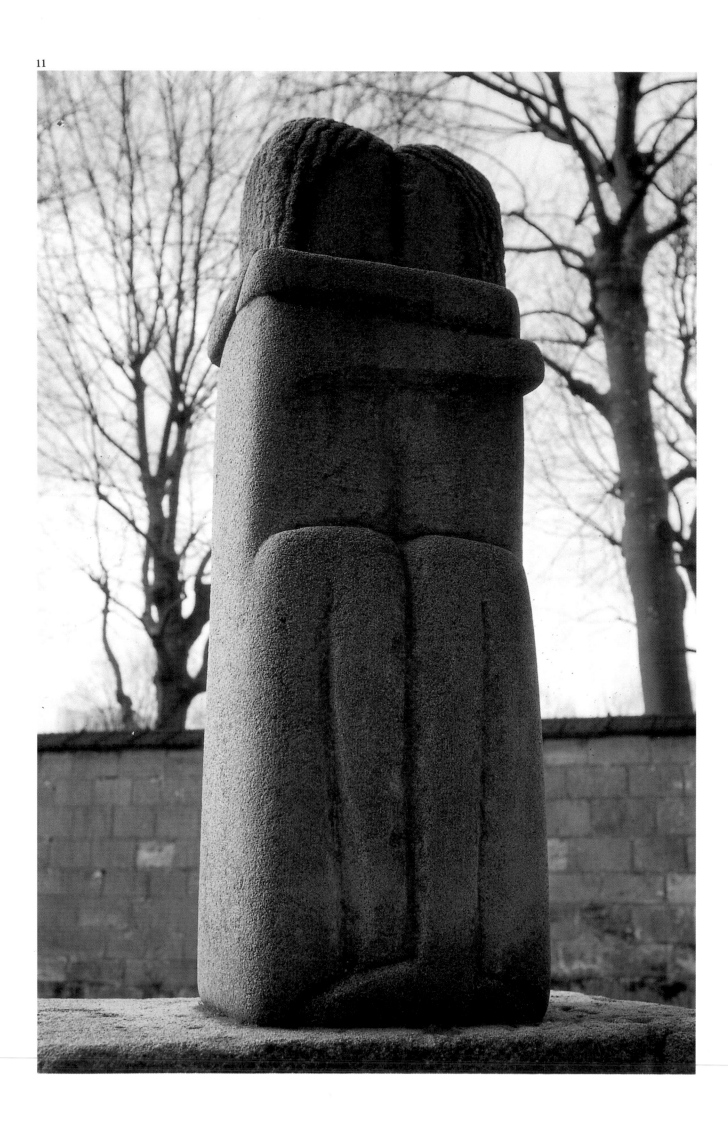

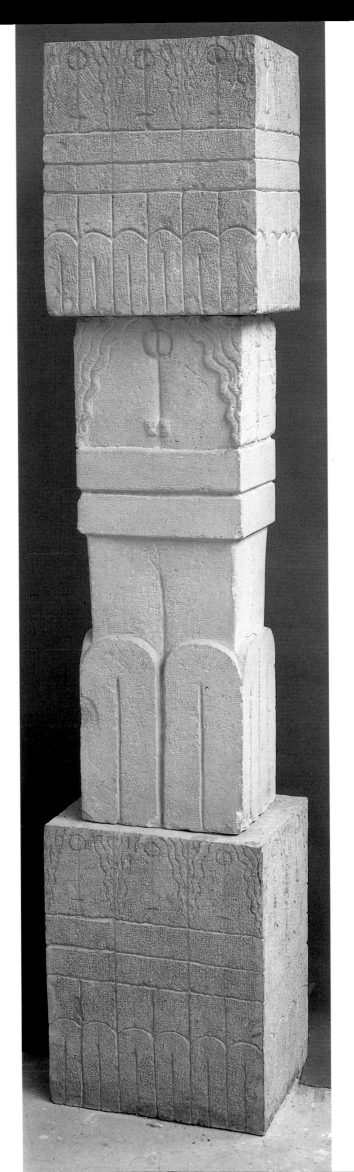

12 Boundary Marker, *1945*

13 *Study for the* Temple
of Deliverance, *c. 1936*

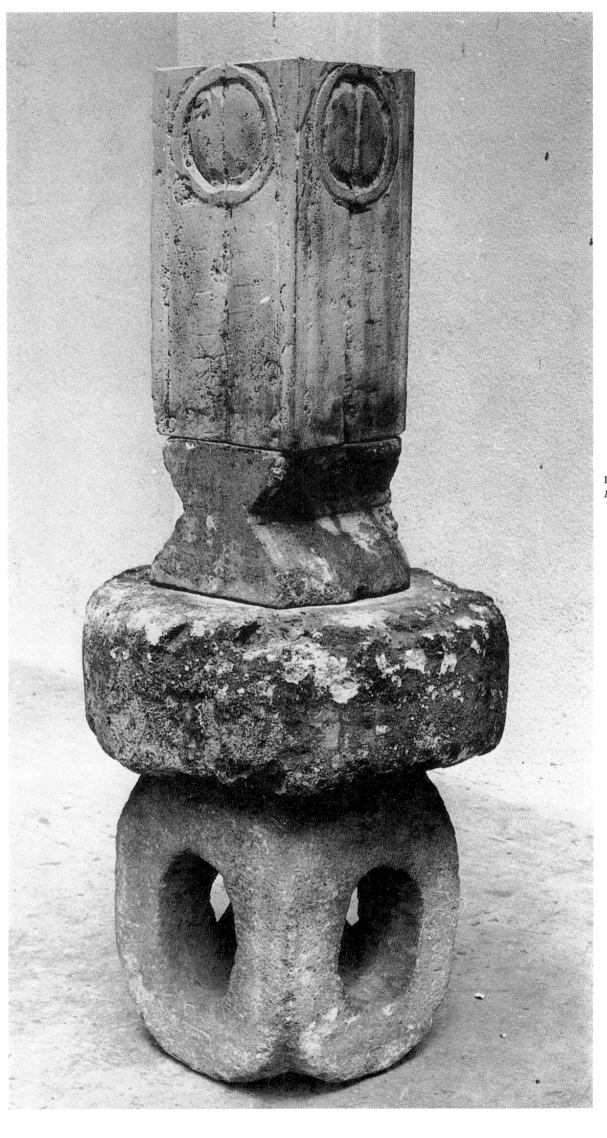

14 The Kiss Column,
1935

The Flight of the Bird

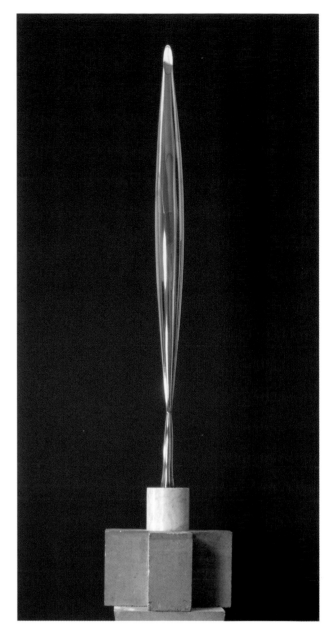

15 Bird in Space, *1940–41*

"My whole life," Brancusi is known to have said, "has been devoted to searching the essence of flight. . . . Flying is such sheer joy!" By its very nature, flight—one of the fundamental themes of the sculptor's oeuvre—takes place high in the sky. The catalogue of the 1933 exhibition of Brancusi's works at the Brummer Gallery in New York describes his *Bird in Space* (plate 16) as follows: "Project of a bird that, once it is enlarged, will fill the sky." The concept behind *Bird in Space* proceeds from his 1910 *Maiastra*, a mythical bird recurrent in a number of Romanian legends and tales. According to his assistants Alexandre Istrati and Natalia Dumitresco, the artist "had meant to portray in one single bird the essence of all birds. . . . He perceived it as a symbol of everything spiritual." This spiritual element, typical of all the "birds" sculpted by Brancusi, was indeed already apparent in the first of them, executed in 1910 while he was still gradually advancing in his quest for a pure form and even before he produced, between 1923 and 1940–45, the many versions of *Bird in Space*, in polished bronze, white, yellow, black, or blue-gray marble, and plaster. Brancusi's numerous interpretations of this work differ because of their varying bases, in the way the elliptical curve is more or less pronounced, as well as in the numerous materials used in their execution.

With this sculpture, Brancusi has created a smooth form whose soaring aerodynamism is solely suggestive of flight, without resorting to any realistic detail whatsoever. It was this absence of realism that, in 1928, caused U.S. Customs officials to challenge this sculpture's validity as a work of art. *Bird in Space* was indeed one of the earliest inceptions of nonrepresentational sculpture.

Brancusi has expressed in this form the sine qua non of all birds, namely the joy of flying: "He didn't have to read books," wrote Mircea Eliade, "to discover that flying amounts to happiness, since it symbolizes ascension and transcendence, the overcoming of the human condition." Beginning in 1923, the same upward dynamic also distinguished the joyful crow of *The Cock* (plates 19, 20, 53). Brancusi's masterly reduction of this particular bird to its simplest formal expression was achieved by emphasizing its forceful lines of salient and reentrant angles.

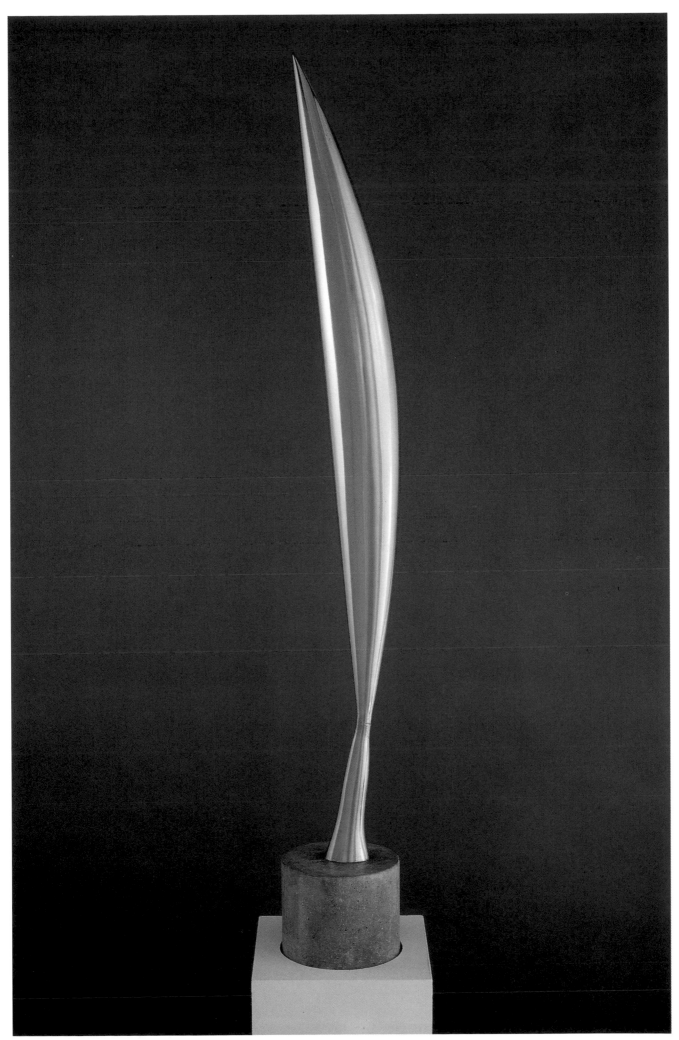

16 Bird in Space, *1930*

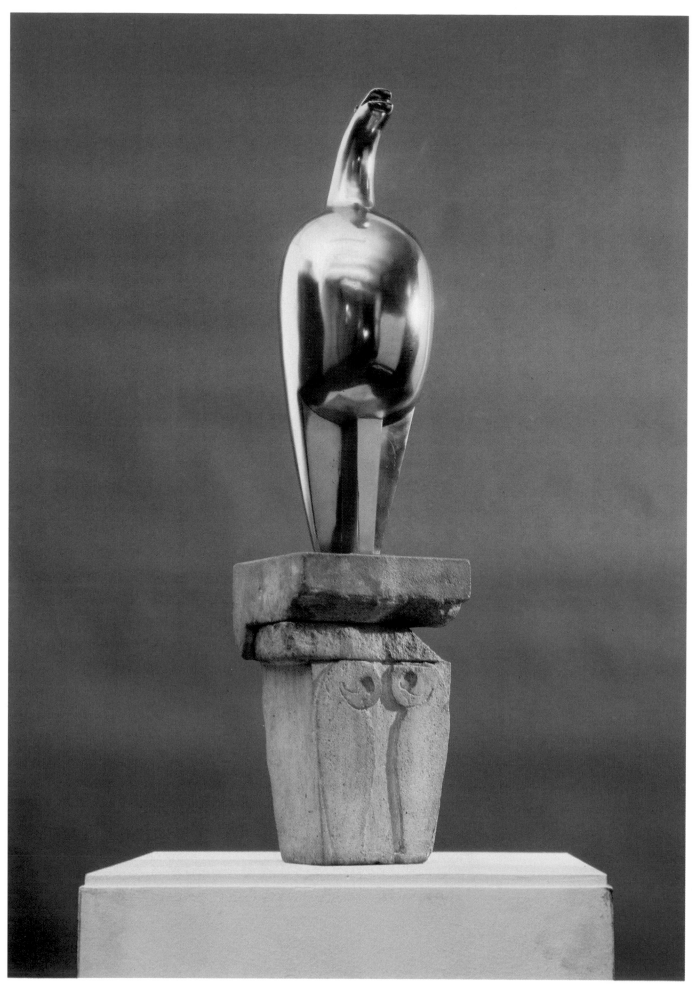

17 Maiastra, *1910–12*

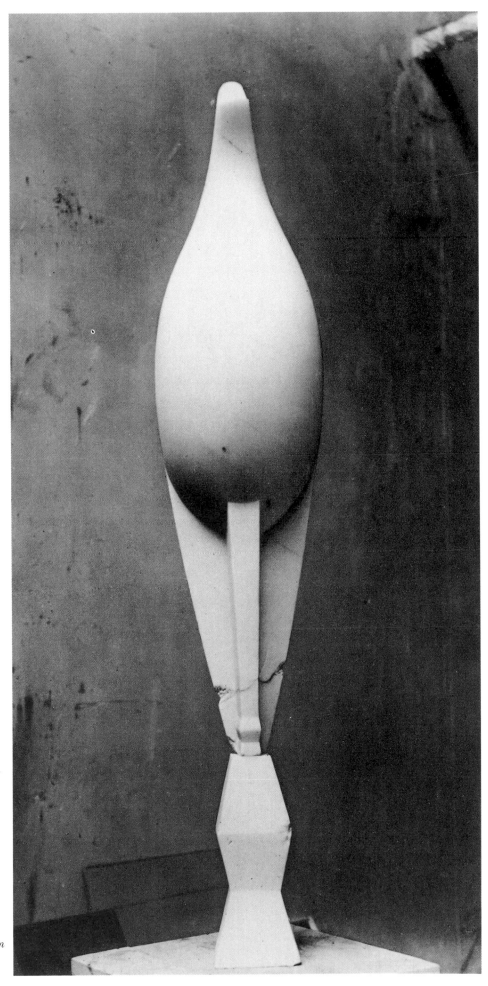

18 Maiastra, *1915. This work was broken
and reworked by the artist. Photograph
by Brancusi*

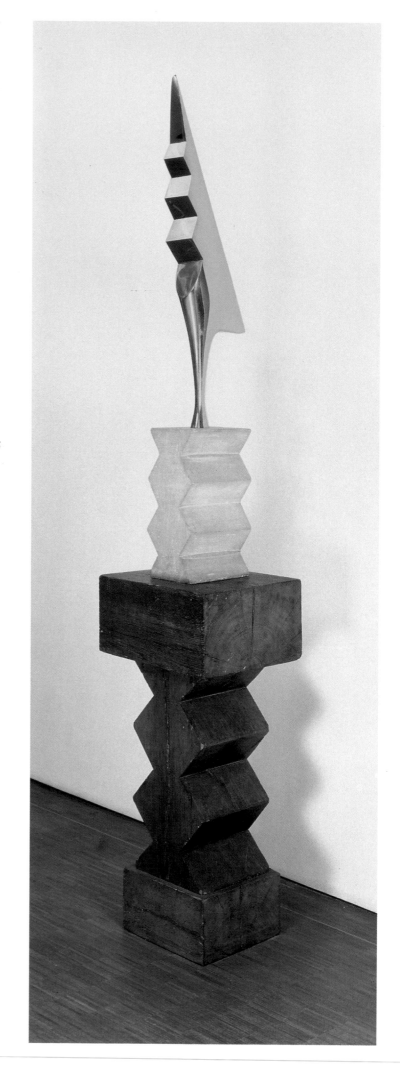

19 The Cock, *1935*

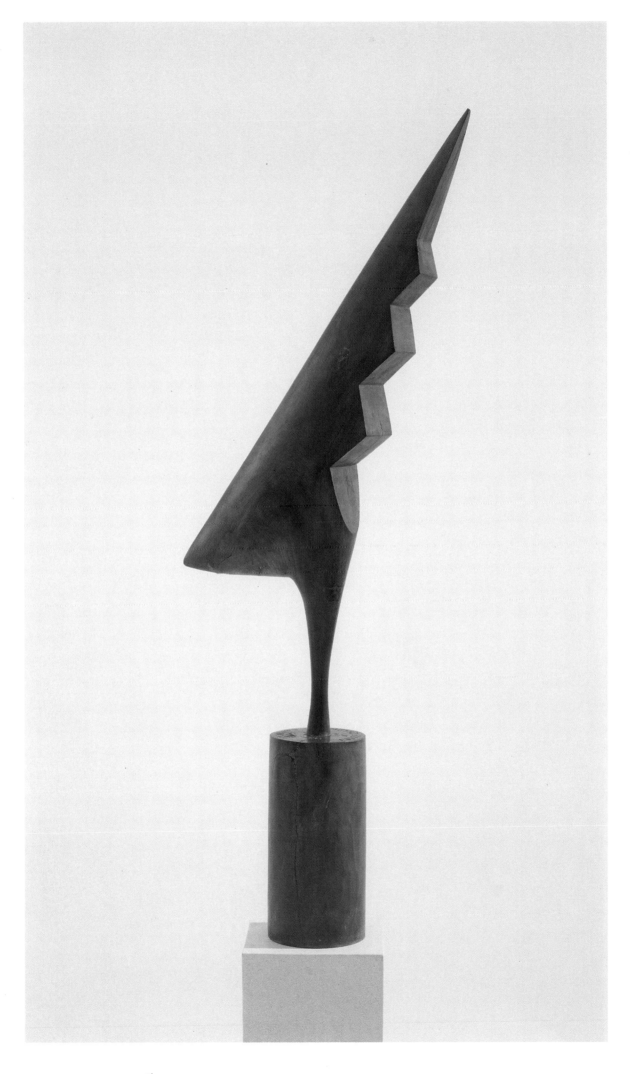

20 The Cock, *1924*

The Ovoid and the Essential Form

The themes of Brancusi's sculptures are always drawn from life: it could be love, as in *The Kiss;* it could be birth as in *The Newborn I,* 1915 (plate 22); or it could be the bodies of his fellow men and women, as in his several torsos (cf. plate 30), heads, and other analogous works. The sculptor endlessly reworked these forms, simplifying and streamlining them; he refined them, gradually tracing them back to an alleged original condition. In his 1909 marble *Sleeping Muse* (frontispiece), only the slight relief of a few remaining traits offers a vague indication of such features as the hair and nose, while the overall form is purified to the point of assuming the perfect shape of an egg. "In the case of the ovoid," Ezra Pound wrote, "I imagine Brancusi wholly absorbed by the notion of a pure form, a form completely independent of all earthly weightiness and endowed with a life as autonomous as that of any geometric form." It was precisely this creative principle that enabled Brancusi to produce incomparably pure portraits such as the several versions of *Mademoiselle Pogany* (plates 25, 26, 27), which suggestively echo some of

21 The Newborn, *1920*

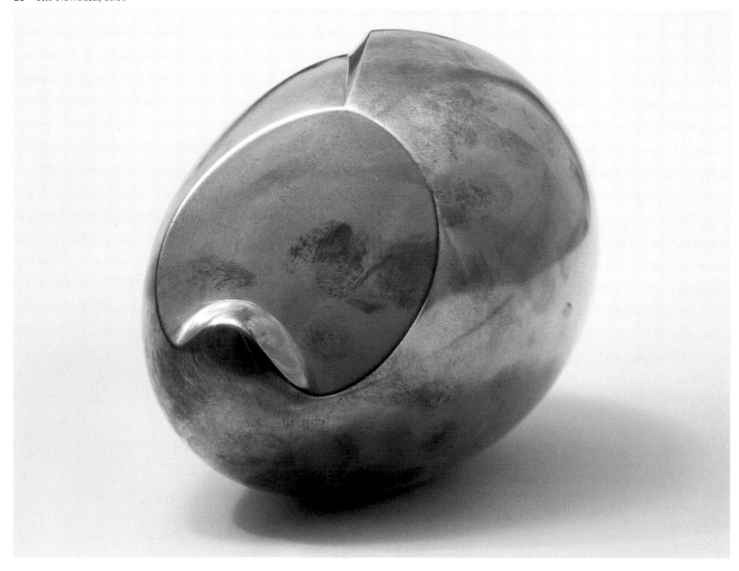

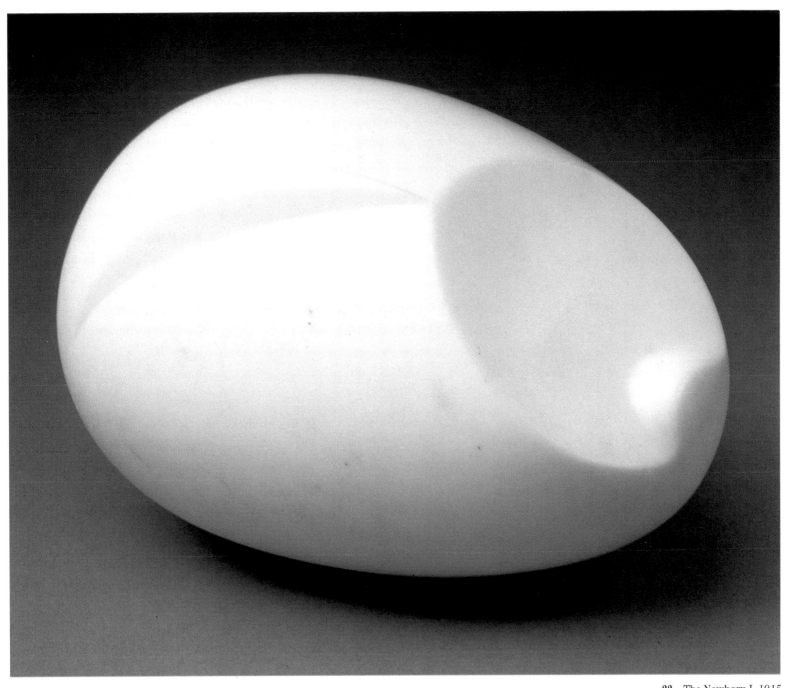

22 The Newborn I, *1915*

the sculptor's *Muses*, namely the 1912 version in white marble and the polished bronze of 1917.

An even more astonishing work is the 1916 *Princess X* (plate 28): "In order to release this entity," Brancusi explained, "in order to bring this timeless type of transient form into the realm of the senses, I had to simplify and scour my work for five long years. That effort, I truthfully believe, has allowed me to transcend matter itself." Distilling a timeless type of transient form and overcoming the boundaries of matter were among the artist's foremost concerns, as witnessed also by such works as the bronze *Torso of a Young Man* (1917) or the onyx *Torso of a Young Woman* (1922), the most finished version in the series.

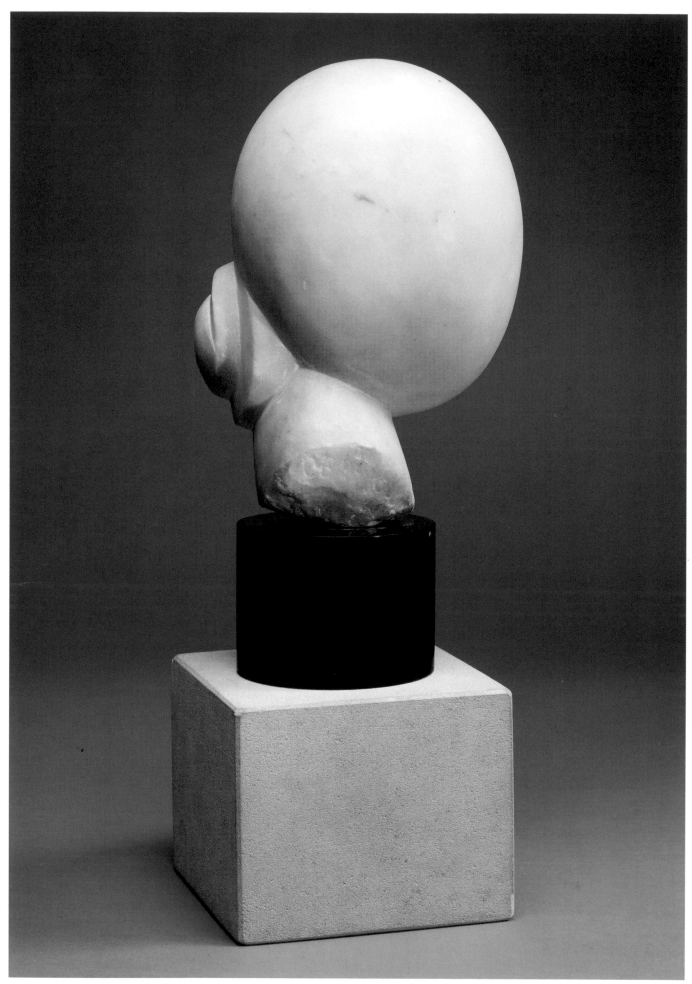

23 Head of a Woman (Abstract Head), *1922*

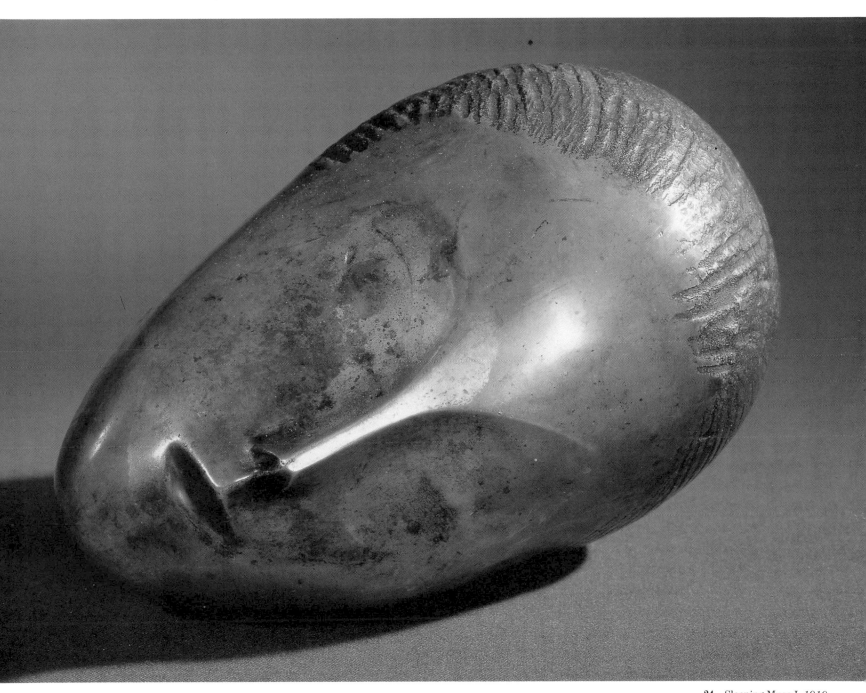

24 Sleeping Muse I, *1910*

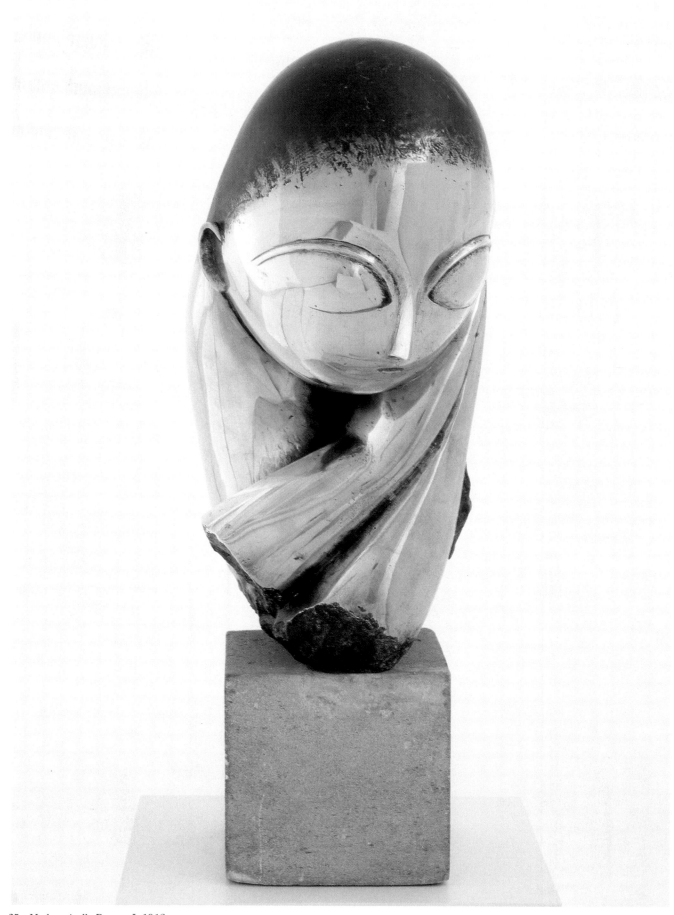

25 Mademoiselle Pogany I, *1913*

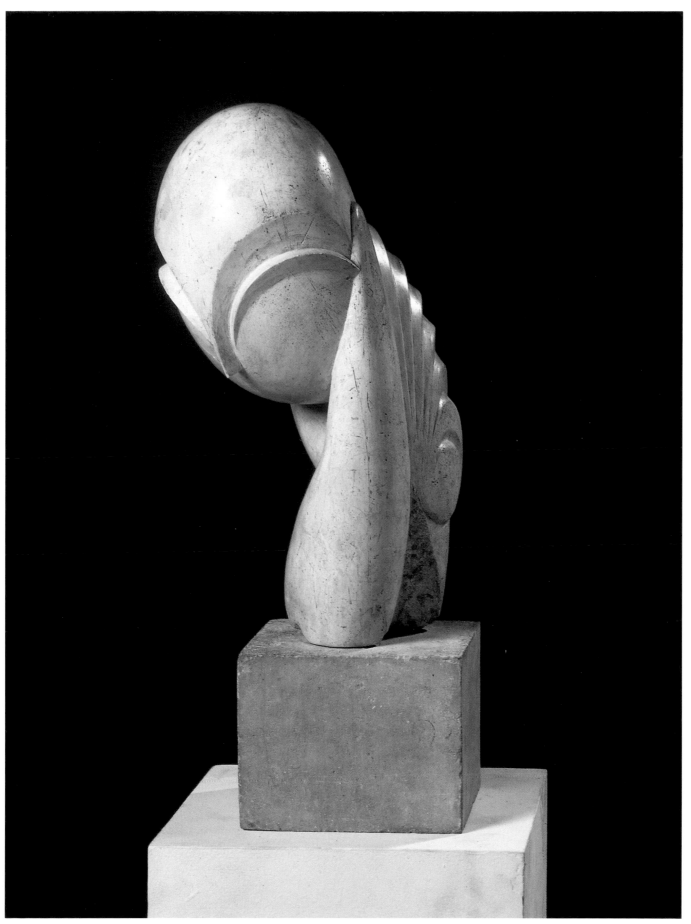

26 Mademoiselle Pogany II, *1925*

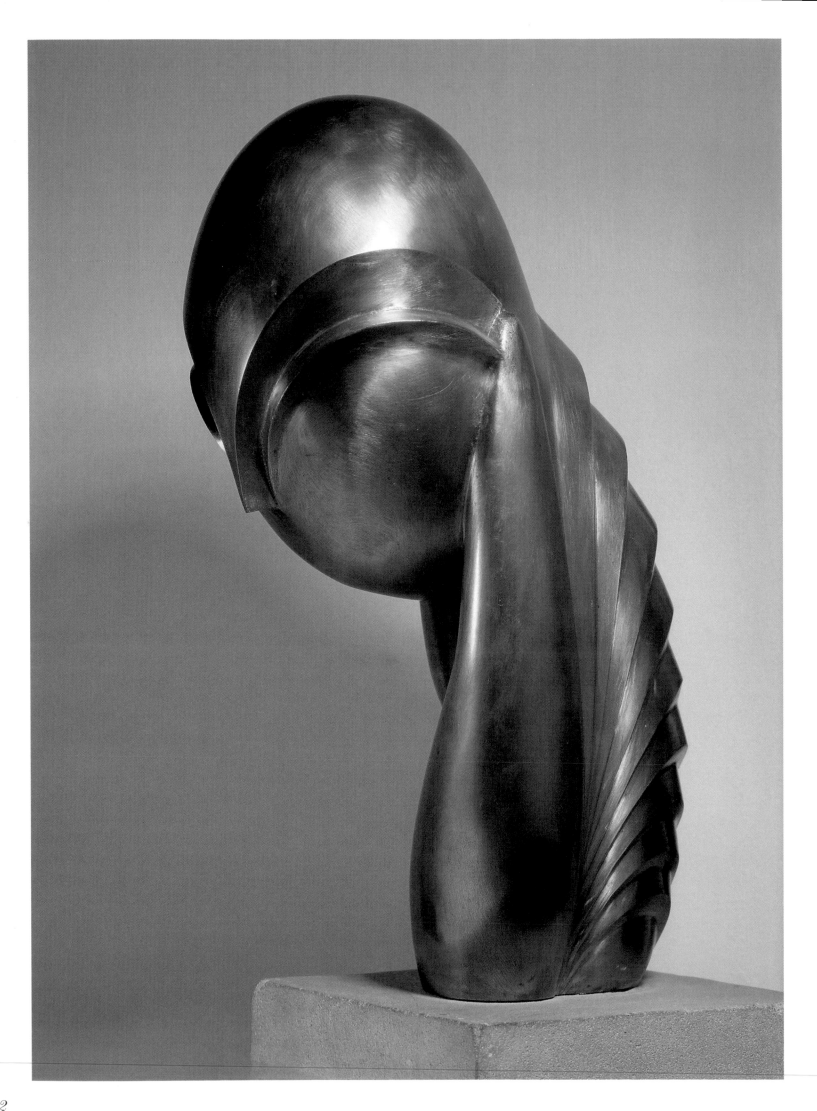

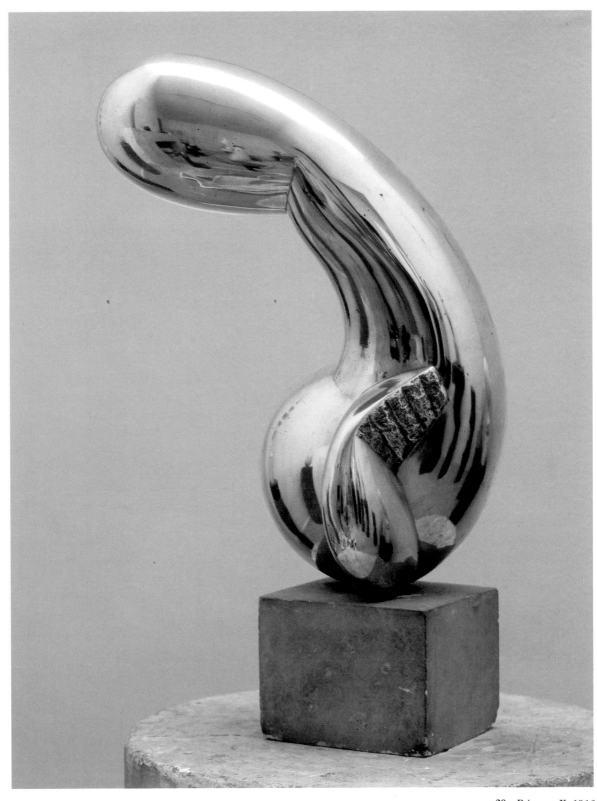

28 Princess X, *1916*

27 Mademoiselle Pogany III, *1933*

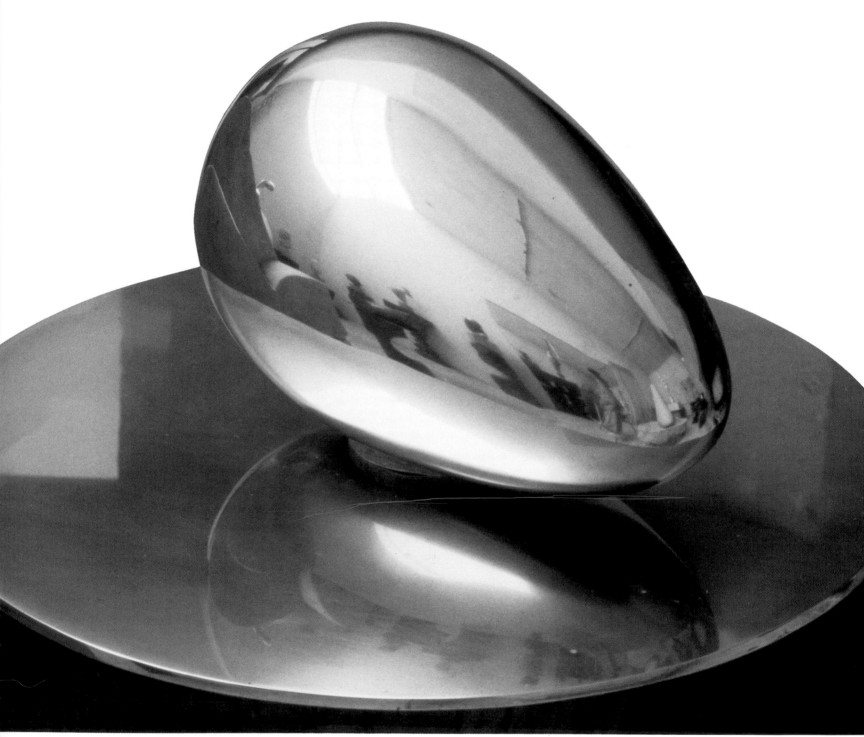

29 Beginning of the World, *1924*

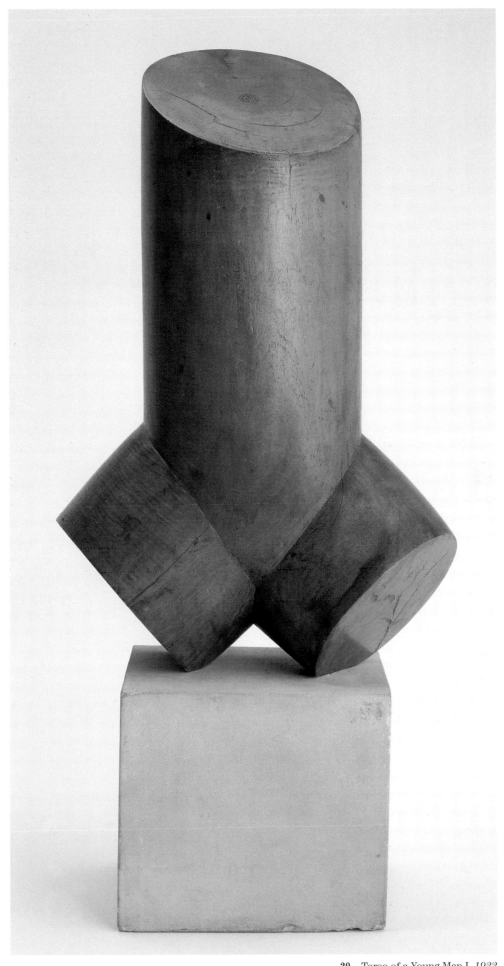

30 Torso of a Young Man I, *1922*

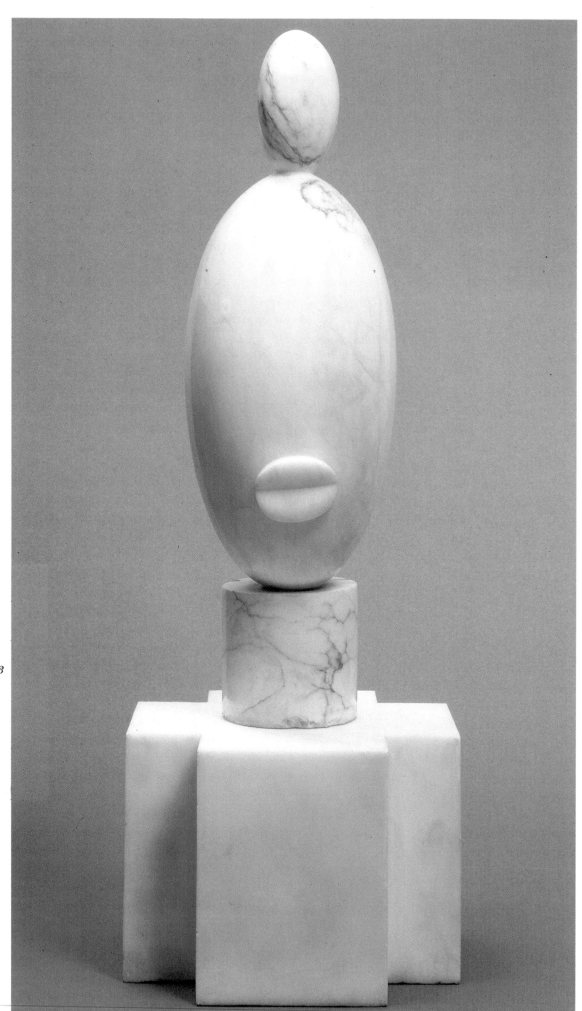

31 White Negress I, *1923*

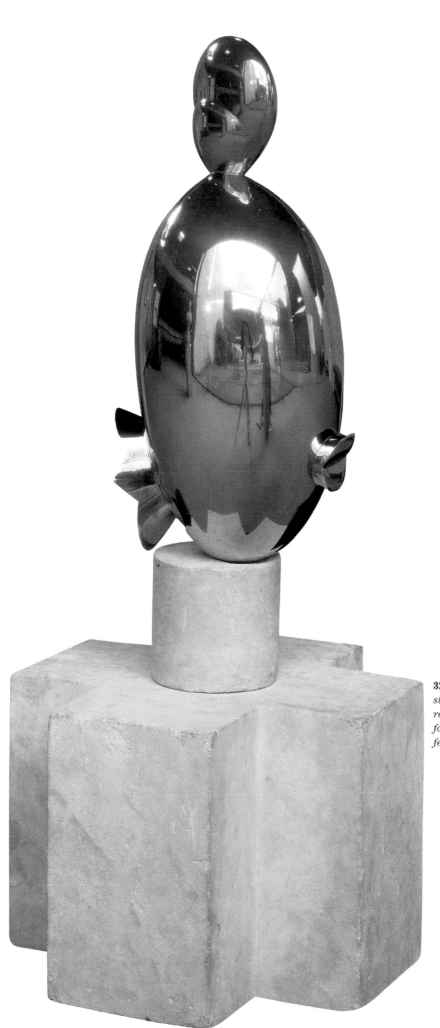

32 Blond Negress I, *1926. The ovoidal form of the strikingly vertical head of the* Blond Negress *(1926) rests directly on its base. The stark simplicity of this form accentuates the figure's only two distinctive features, namely the lips and the coiffure.*

Direct Carving and Polish

Inspired by the architecture of his native country, Brancusi harbored a kind of immemorial and mythical remembrance of wood. Nevertheless, from 1907, he also worked in stone and marble. He always treated plaster merely as a working step toward polished bronze. In 1914, Brancusi began sculpting wood using the technique known as direct carving—without the use of preliminary studies, that is—and created such works as *Little French Girl*, 1914 (plate 33); *Chimera*, 1915 (plate 34); *The Sorceress*, 1916 (plate 37); *Adam and Eve*, 1921 (plate 35); and *Socrates*, 1922 (plate 36). For Brancusi, direct carving was a means of achieving complete engagement in the creative process: "Direct carving," he once stated, "is the genuine path to sculpture, but it is also the worst for those who do not know how to walk it. Direct or indirect carving, however, is quite an irrelevant issue: it's what it has done that really counts."

What was truly important to Brancusi, what he aspired to with uncompromising rigor, was the most congruous correspondence between the materials employed in each work of art and the idea that the piece sought to evoke. This idea would have to arise from matter itself. Evidence of this is afforded, among other examples, by his 1922 *Fish* (plate 38), whose motion through water is suggested by the streaks in the marble, or by his 1943 *The Seal II* (plate 40), in which the blue-gray marble's striation follows the form's own upward movement.

Brancusi exhibited the same preoccupation with perfection in his treatment of the surfaces of polished bronze: "Polish is a necessity dictated by the relatively absolute forms realized with certain materials. It is not mandatory. In fact, for certain other forms, it can even be detrimental." Indeed, this sensitivity to materials was no less critical to Brancusi's genius than the choice of his motifs.

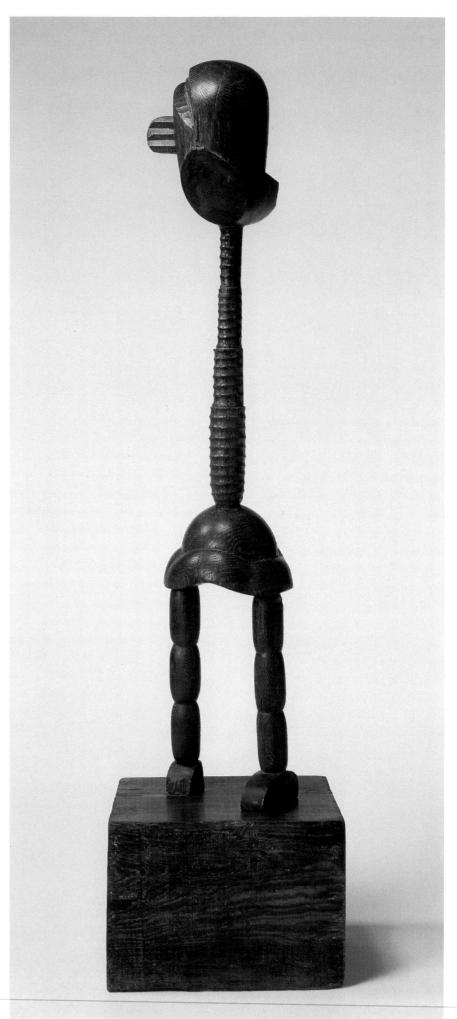

33 Little French Girl, *1914*

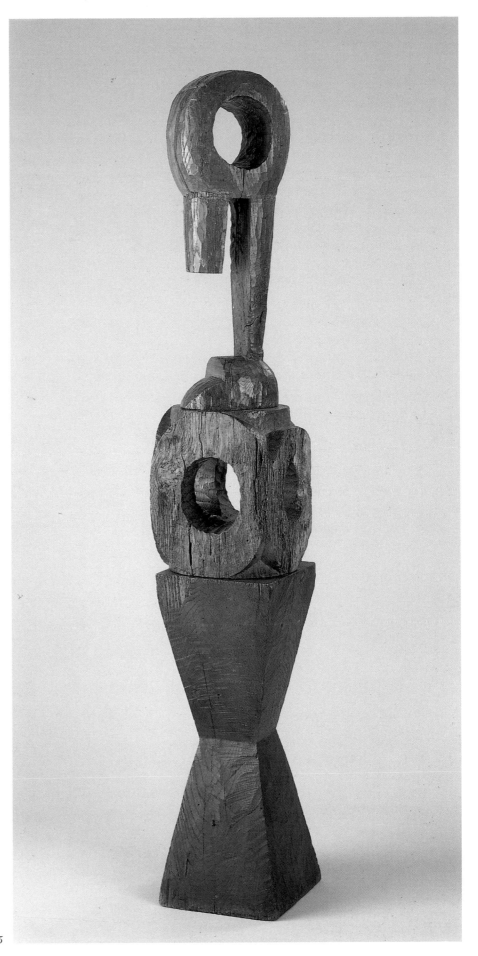

34 Chimera, *1915*

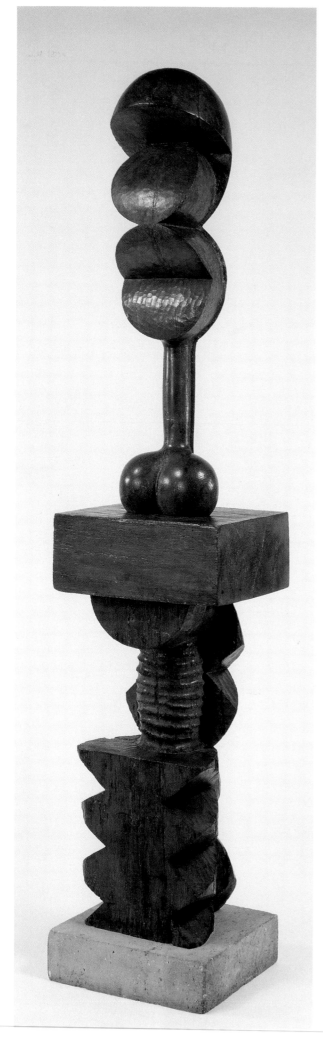

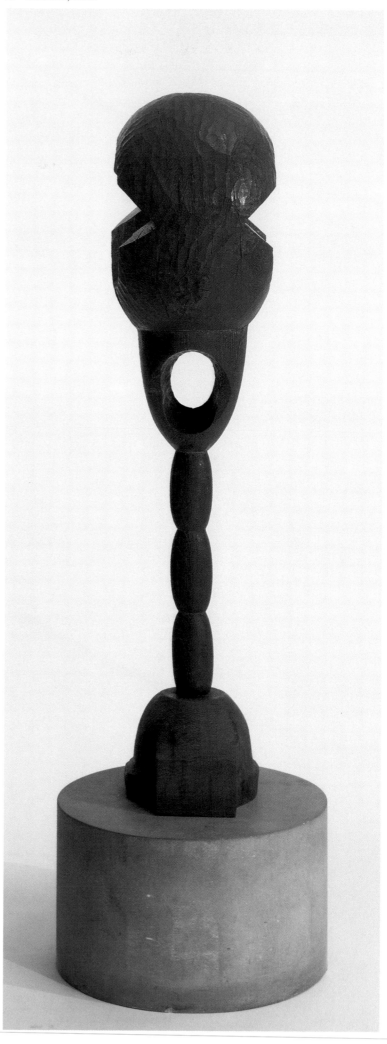

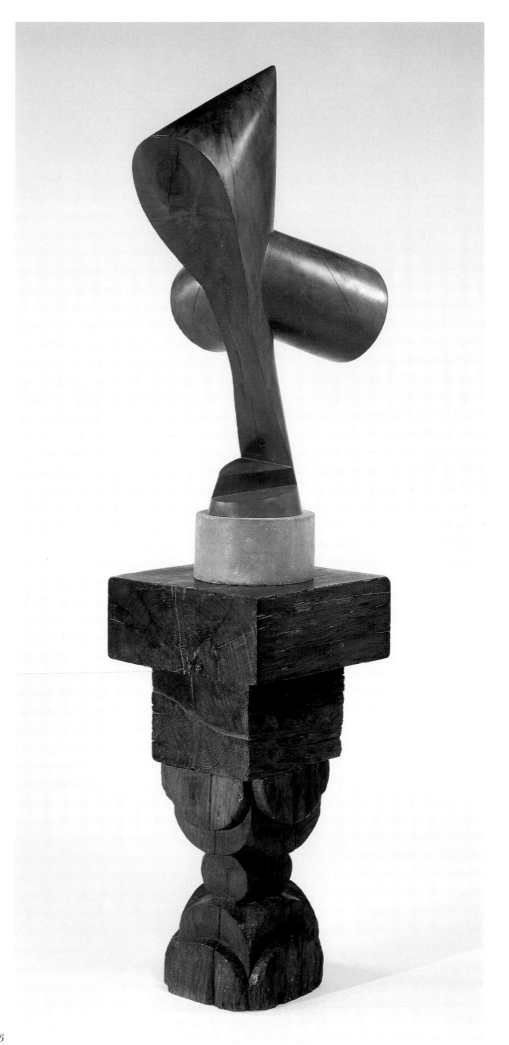

37 The Sorceress, *1916*

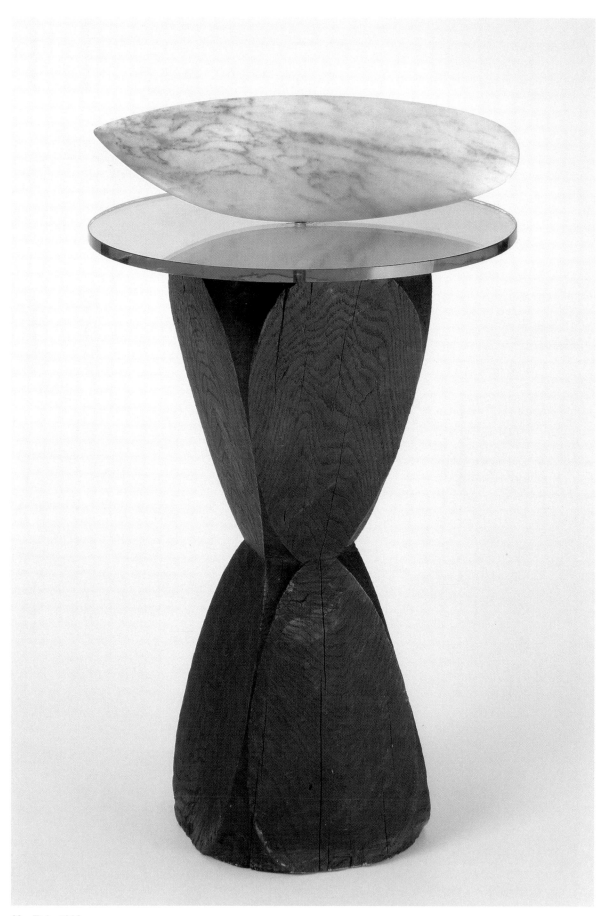

38 Fish, *1922*

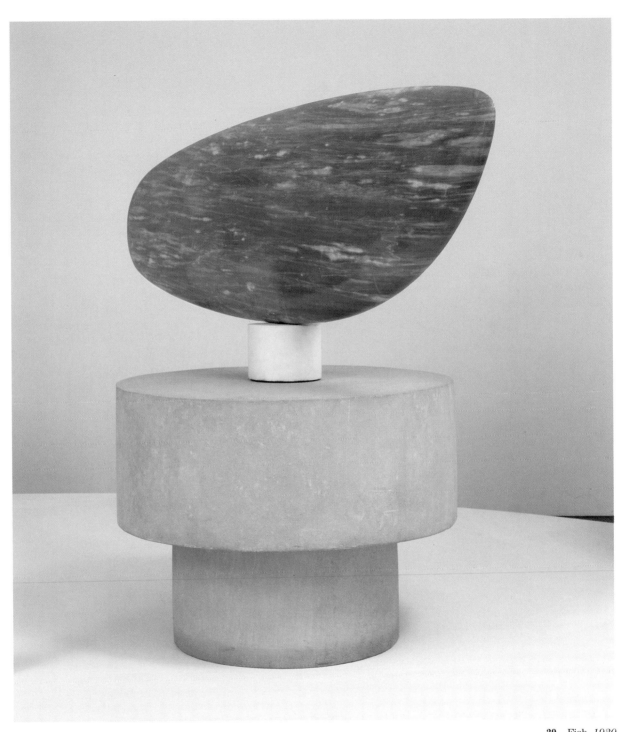

39 Fish, *1930*

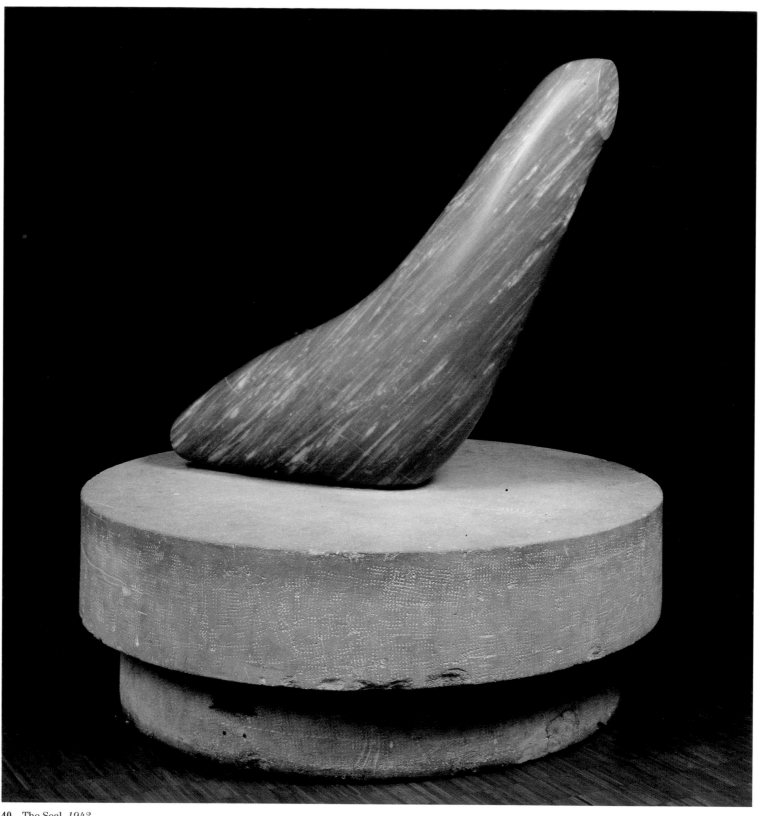

40 The Seal, *1943*

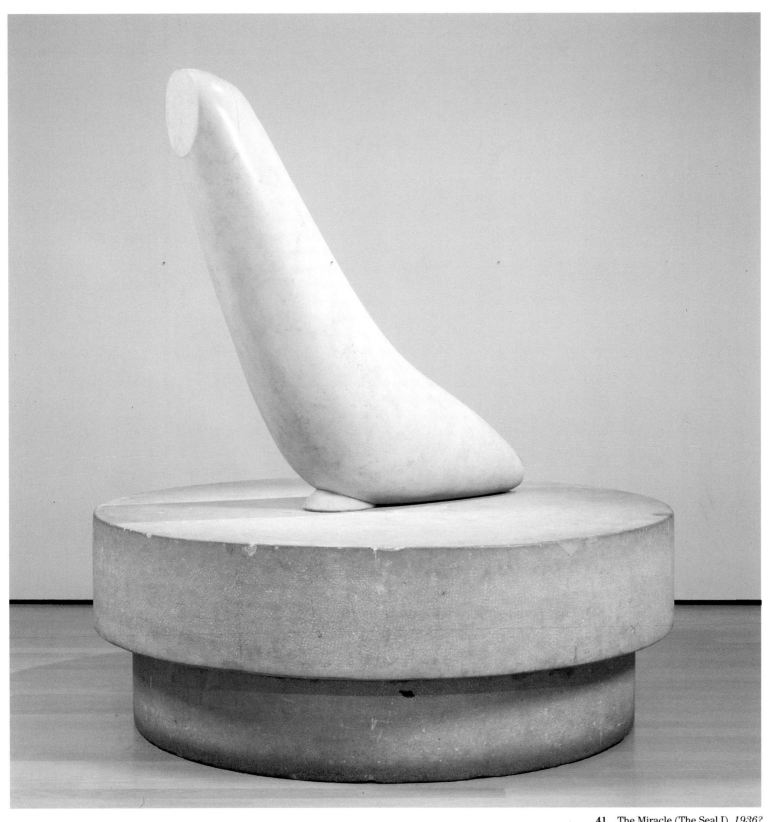

41 The Miracle (The Seal I), *1936?*

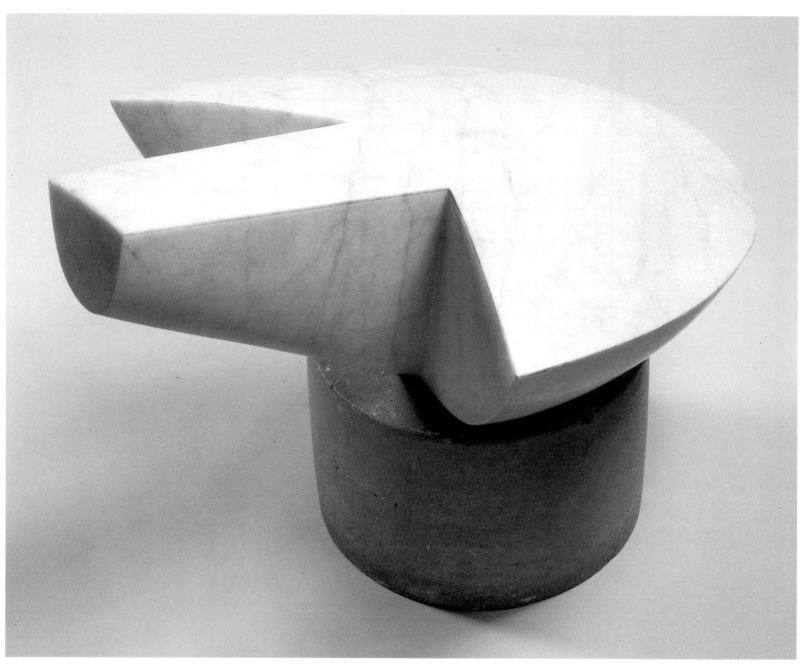

42 The Flying Turtle (The Turtle), *1943. When it
was first exhibited at the Guggenheim Museum in
New York in 1955,* The Turtle *was mounted and
photographed upside down. "My turtle is now flying,"
Brancusi said to Istrati and Dumitresco. However,
he did not warn the curators, and* The Turtle *became*
The Flying Turtle.

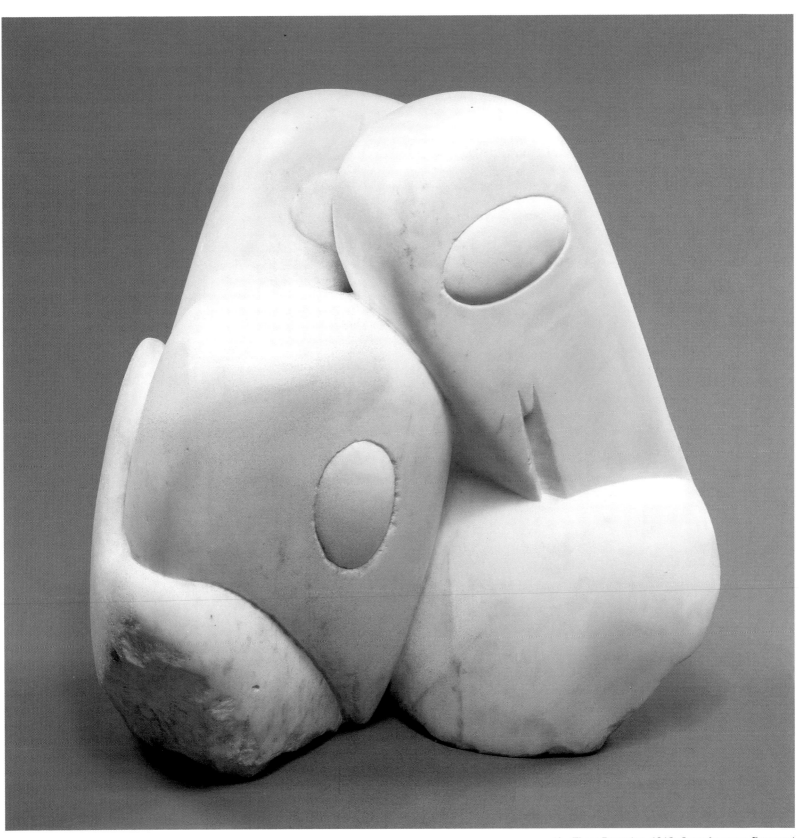

43 Three Penguins, *1912. Over the years Brancusi created his own original bestiary. Three Penguins (1912) and Two Penguins (1914) are particularly important because, in these works, the artist first tackled the problems associated with creating a harmoniously self-contained sculptural group.*

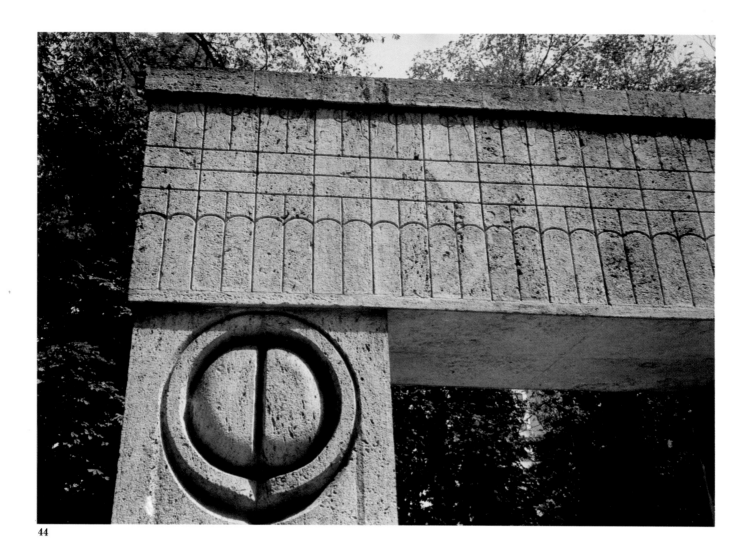

44

The Tîrgu Jiu Memorial

The creation of a monument to the soldiers who, in 1916, pushed back the German invasion of Romania at Tîrgu Jiu, near the Jiu river, was entrusted to that country's eminent son, the artist Constantin Brancusi. The sculptor first surveyed the site in 1937 and quickly determined the best locations for his three works: the *Table of Silence* (plate 47), the *Gate of the Kiss* (plates 44, 45, 46), and the *Endless Column* (plates 48, 49, 50). The ensemble is installed over a mile-long axis that runs perpendicular to the river. Together, the three monuments provide a unique sculptural experience, inviting the visitor to a deeper kind of meditation than what may normally be required by a naturalistic representation of a war episode.

First one encounters, among the trees of a municipal park, the *Table of Silence* (7′ [2.15 m] diameter), which is made of Bampotoc travertine. It is composed of two overlying round stones and twelve surrounding stools, each one formed by two superimposed hemispheres of stone. A path bordered by stones leads to the Bampotoc travertine structure of the *Gate of the Kiss*, composed of two pillars and a lintel, and on whose four sides the theme of the kiss is repeated altogether forty times. The gate's dimensions (16′10″ × 21′2″ × 5′6″ [5.13 × 6.45 × 1.69 m]) are in accordance with the golden section. The overall design of the monumental complex appears to have been

44, 45, 46 Gate of the Kiss, *1937–38.*
Tîrgu Jiu

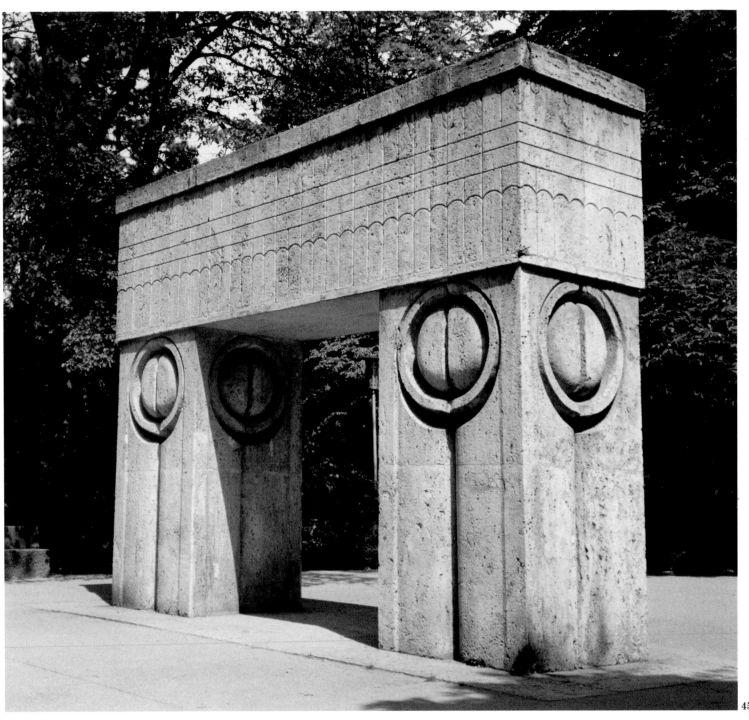

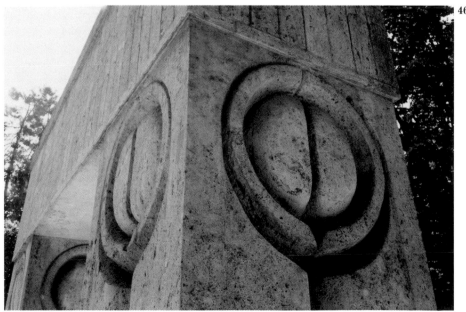

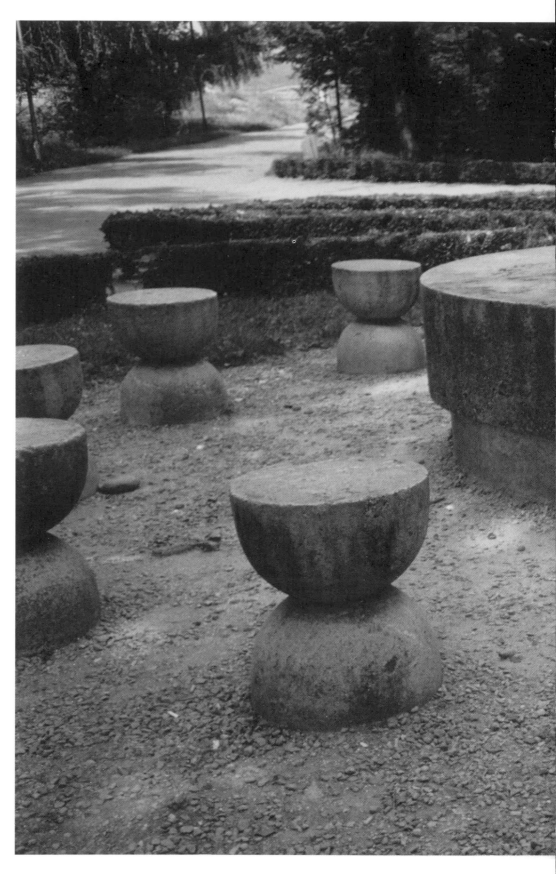

arranged in such way as to inspire visitors to meditate on death and love before they proceed to contemplate infinity. At the far end of the axis, the gaze is carried up by fifteen stacked elements—plus two half-elements on both ends—which constitute the *Endless Column* (96′3″ [29.35 m]). The structure alludes to the ancient idea of a mythical column that links the earth to the heavens.

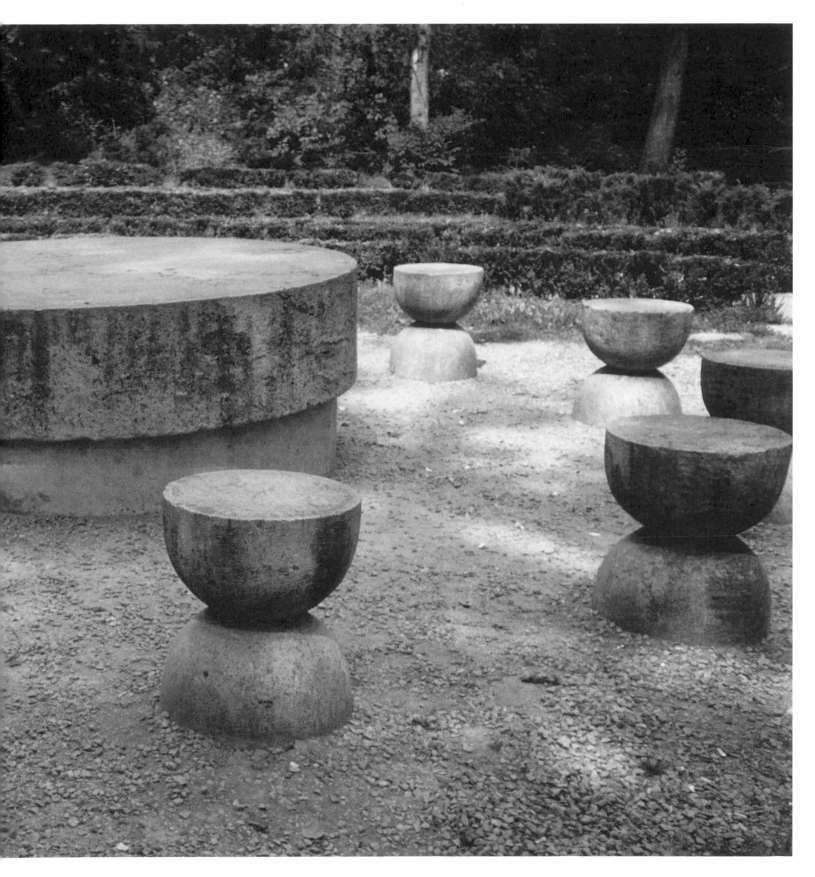

The Tîrgu Jiu memorial, Brancusi's only public sculpture, allowed the artist to develop in concrete fashion his haunting preoccupation with the harmonious relationship of a sculpture to its environment. The only other instance—and then only theoretically so—of a comparable development is his project for the *Temple of Deliverance* (see page 9 and plate 13), which, regrettably, never saw the light of day.

48, 49, 50 Endless Column, *1937–38.*
Tirgu Jiu. This endlessly rising vertical
sequence of symmetrically repeated
elements is made of cast-iron and finished
with a spray coat of brass. The structure
was erected under the technical
supervision of chief engineer Ştefan
Georgescu-Gorjan.

48

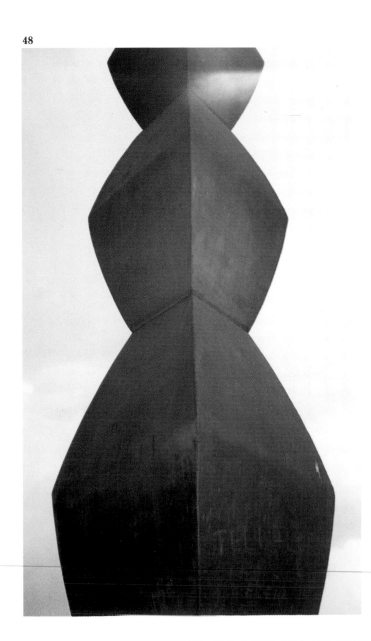

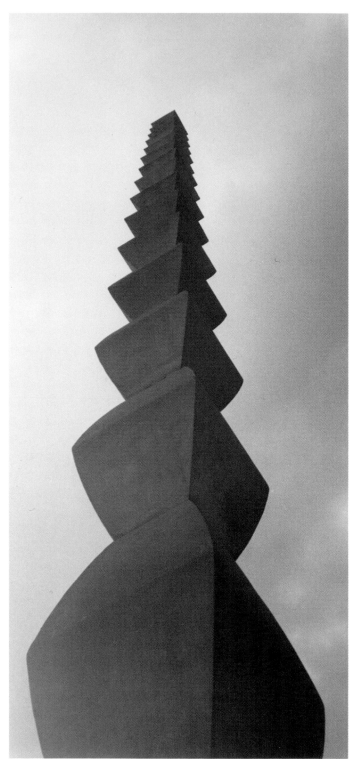

49

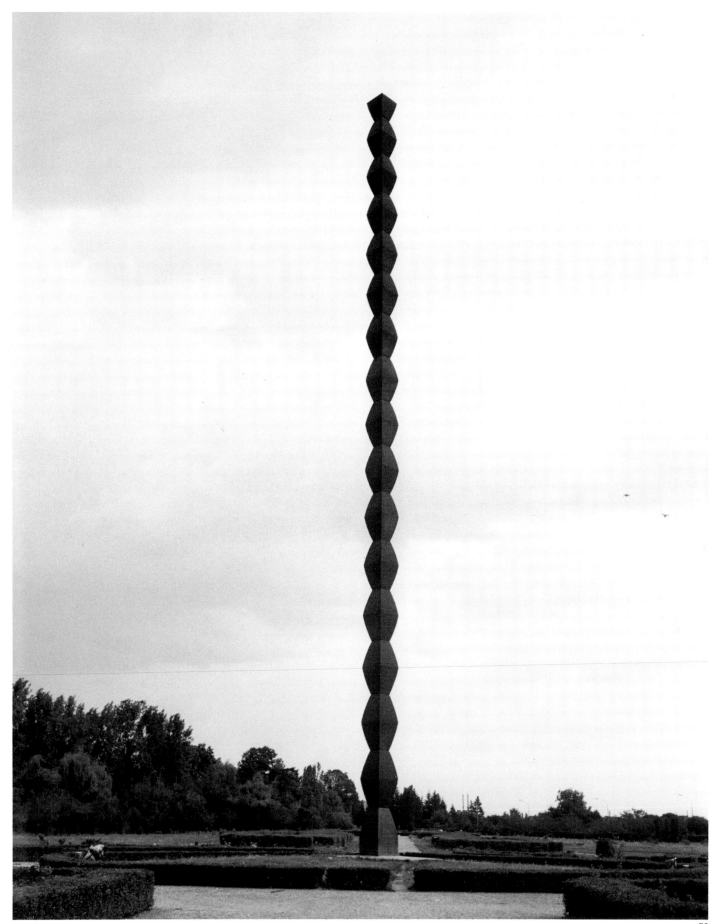

Brancusi Photographed by Brancusi

Brancusi's photography provides direct access to the most intimate aspects of his creative activity, thus affording a greater understanding of it. More than a mere tool for personal reference, Brancusi's photographs were a means of explaining his work and constitute an important part of his contribution to twentieth-century art. Indeed, Brancusi preferred that no one else take pictures of his works or his studio. He also shot photographs of himself, both at work and at rest, in a considerable number of self-portraits.

One of the artist's earliest (c. 1901) photographic documents (plate 52) shows his own *Écorché* alongside a plaster of *Antinous*, whose graceful posture Brancusi's flayed man replicates. A skeleton stands in the background; in the foreground, sits *Head of a Woman*, a study dating from 1900. While still in Romania, then, Brancusi had carefully attempted to reveal unexpected links between the beauty of Antinous; the skeleton, which represents death; and his own *Écorché*. The presence of the portrait bust in the foreground, however, somewhat lessens the powerful impact of their association.

Early on, Brancusi had used photographs merely as a way of documenting his work, but later—around 1907–8, that is, when he adopted the direct carving technique, forcing himself to forgo the intermediary stage of plaster—he relied on photography to help him address certain plastic issues that he encountered along the way. It was not until near the end of World War I that he began to photograph his sculptures in a methodical manner: freestanding from a range of different angles; grouped together according to subtle correspondences; or even in their own ultimate location, the most widely known example being that of the *Endless Column* set against the background of a sky filled with fleeting clouds (plate 54).

It is known that, in 1921, Brancusi sought some practical advice from Man Ray, who later wrote: "I showed him how to take pictures and how to process them in the darkroom. From that moment on, he continued on his own without ever consulting me again."

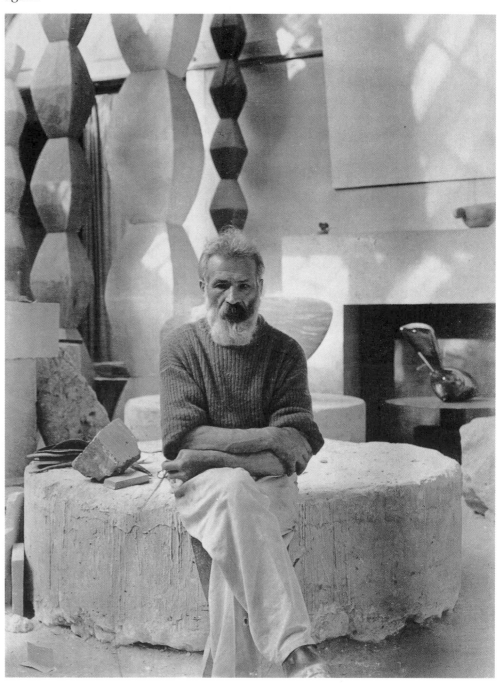

51 *Self-portrait of the artist in his studio, c. 1933–34. Immediately behind Brancusi,* Fish, *and to his left,* Leda.

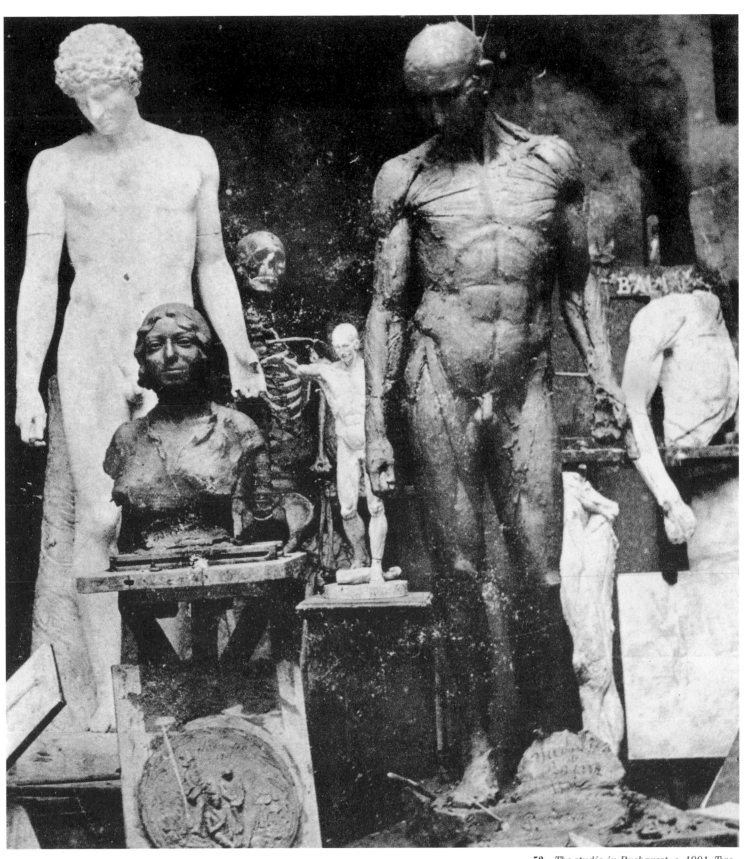

52 *The studio in Bucharest, c. 1901. Two versions of the* Écorché *and, left, a cast of the classical* Antinous *from which Brancusi drew inspiration for his piece.*

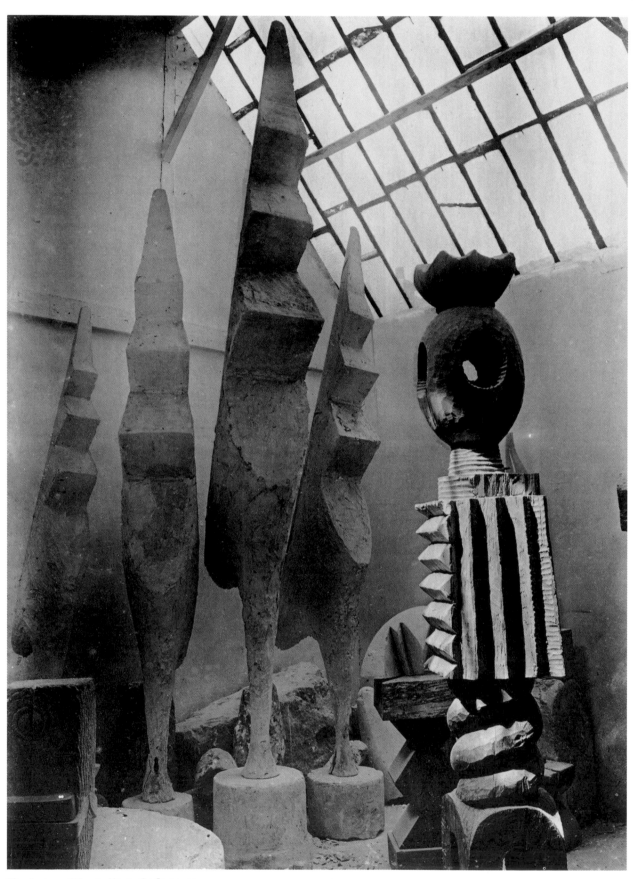

53 *A view of the studio on the Impasse
Ronsin, c. 1945–46.* Four Grand Coqs *and,
in the foreground,* King of Kings.

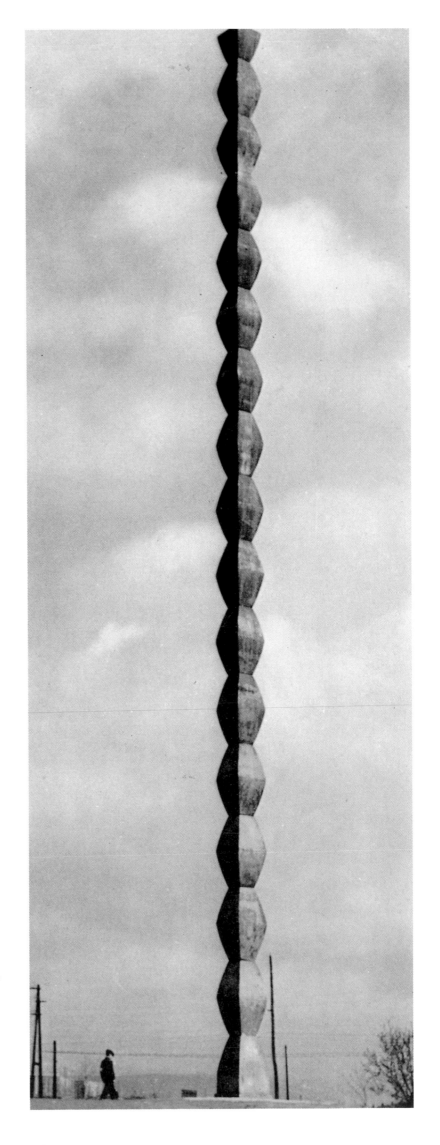

54 Endless Column, *1937–38.*

The Artist's Studio

Brancusi spent some forty years of his life in either one or the other of his Parisian ateliers on the Impasse Ronsin. There—little attuned to city life—the artist spent long hours meditating, surrounded by his own sculptures, which he painstakingly carved, polished, and photographed. Whenever a new work began to take shape and emerge from raw matter, it could be immediately compared with other works in the studio. Brancusi always retained at least one piece from each phase of his career. Visitors thus found themselves in a position to take in and appreciate the artist's evolution in its entirety and to ponder the manifestations of all the ideas that had informed his life.

Everybody who had a chance to witness this very special environment agreed that quiet and clarity were its two most outstanding attributes, and that the place emanated a definite sense of temporal absoluteness. In Henri Goetz's words, "one is completely surrounded by imposing bronzes concealed by protective covers, by monuments made of stone or plaster, by wooden statues and columns,

all ready to elicit from the onlooker not only astonishment but above all respect."

Inside the studio—as documented by countless photographs taken by the artist—his works were indeed arranged with the utmost care so as to reveal their mutual relations. Thus his photographs also contribute to our understanding of the subtle but important dynamics of the intuitive measures and dimensions—always abiding by the golden section, albeit based on observation, and not by cold calculations—that the sculptor patiently elaborated in this cloistered environment. Here, the different materials freely engaged in a harmonious dialogue without clashing with one another: the various *Cocks* would crow to each other, and the ethereal forms of the several *Birds in Space* opposed their slender ellipses to the scattered ovoids resting on large thin bases. Even the tools and other functional objects, including the furniture—which Brancusi always personally designed and crafted—were harmoniously attuned to the solemn yet simple presence of his sculptures.

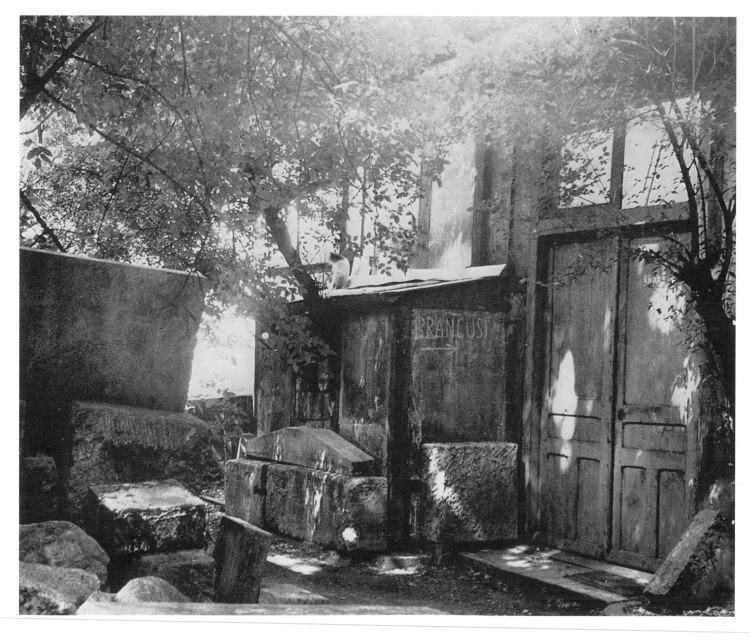

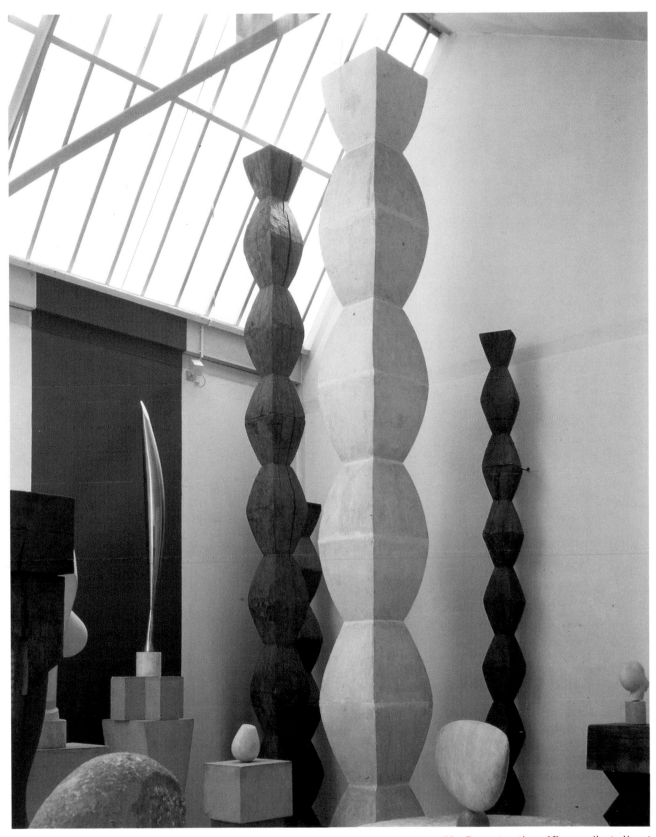

56 *Reconstruction of Brancusi's studio, at
the Musée National d'Art Moderne, Centre
Georges Pompidou, Paris*

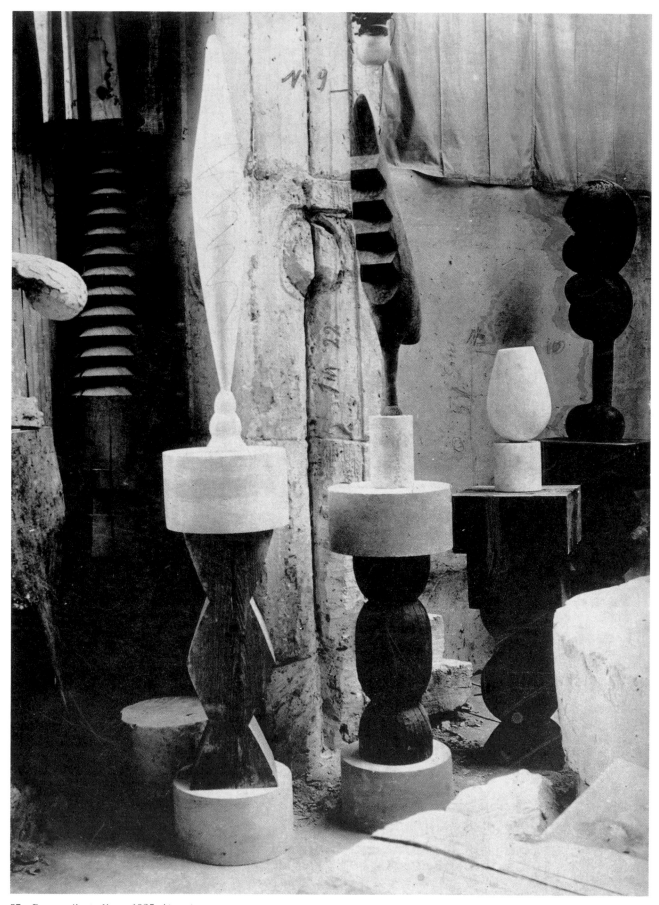

57 *Brancusi's studio, c. 1925. At center:*
Bird in Space, Column of the Kiss, The
Cock, *and* Torso of a Girl. *Photograph by*
Brancusi

58 Bird in Space, *1925. Photograph by*
Brancusi

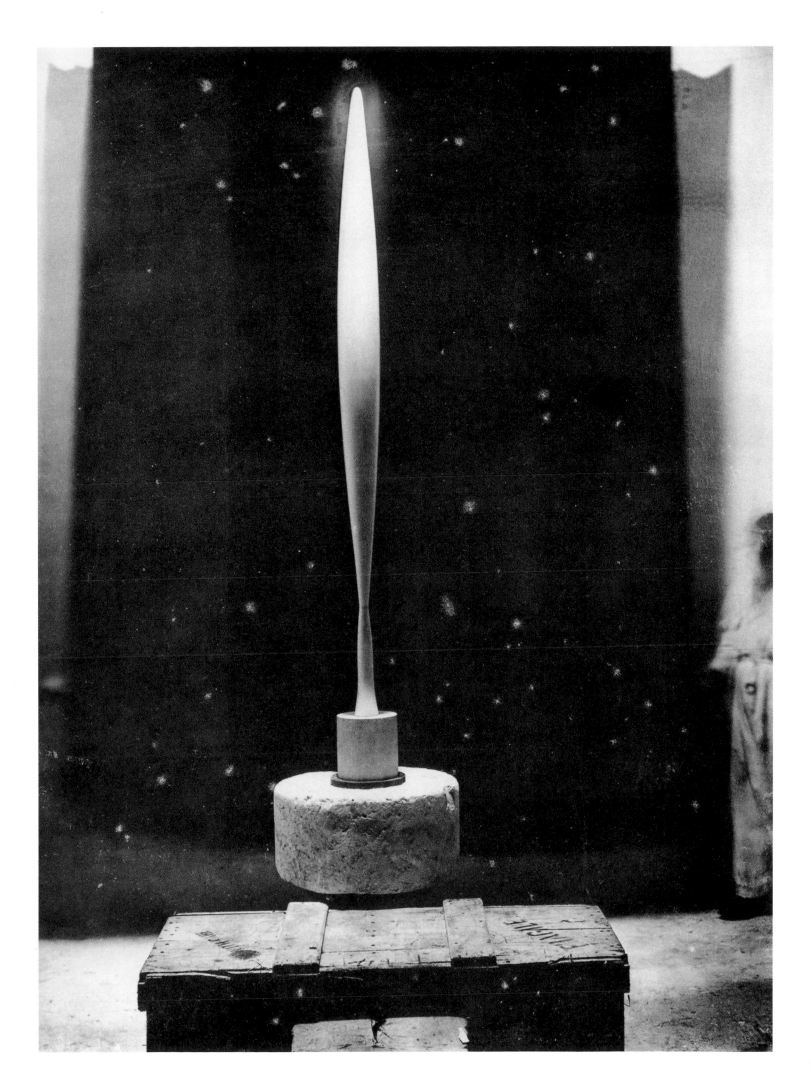

61

List of Plates

1 General Dr. Carol Davila, *1903. Relief: plaster, 28 × 24 × 13"
(71 × 61 × 33 cm). Military Medical Institute, Bucharest. Photograph
by Brancusi*

2 Vitellius, *1898. Plaster, 24 × 16⅞ × 10⅝" (61 × 43 × 27 cm).
Muzeul de Artă, Craiova*

3 Anatomy Study, *1902. Clay. Whereabouts unknown. Photograph by
Brancusi*

4 Portrait of Nicolae C. Dărăscu, *1906. Bronze, 26⅛ × 18¾ × 10½"
(66.3 × 47.6 × 26.8 cm). Muzeul Național de Artă, Bucharest*

5 The Child, *1906. Bronze, 13½ × 10⅛ × 8⅞"
(34.2 × 25.7 × 22.5 cm). Muzeul Național de Artă, Bucharest.
Photograph by Brancusi*

6, 7, 8 The Kiss, *1907. Stone, 11 × 10¼ × 8½" (28 × 26 × 21.5 cm).
Muzeul de Artă, Craiova*

9, 10, 11 The Kiss, *1909. Stone, 35 × 11¾ × 7⅞" (89 × 30 × 20 cm).
Base: stone, 61 × 25¼ × 13" (155 × 64 × 33 cm). Installed in 1911 on
the grave of Tatiana Rachewskaia in Montparnasse Cemetery, Paris.
Photo: Antoine Stéphani*

12 Boundary Marker, *1945. Stone, 72⅝ × 16⅛ × 12"
(184.5 × 41 × 30.5 cm). Musée National d'Art Moderne, Atelier
Brancusi, Centre Georges Pompidou, Paris. Photo: Flammarion*

13 Study for the Temple of Deliverance, *c. 1936. Drawing,
10⅞ × 16½" (27.5 × 42 cm). Archives Istrati-Dumitresco*

14 The Kiss Column, *1935. Four pieces: 1. plaster (pillar for the
maquette of Gate of the Kiss), 13 × 6¾ × 6¾" (33 × 17 × 17 cm);
2. X-shaped stone, 5⅞ × 5⅞ × 7⅛" (15 × 15 × 18 cm); 3. plaster, 5⅞"
(15 cm) high × 15⅜" (39 cm) diameter; 4. sculpted stone,
12⅝ × 9¼ × 9⅞" (32 × 23.5 × 25 cm). Collection Istrati-Dumitresco,
Paris*

15 Bird in Space, *1940–41. Polished bronze, 76¼" (193.6 cm) high ×
18⅞" (48 cm) max. diameter × 3⅜" (8.6 cm) min. diameter.
Cylindrical base: marble, 7¼" (18.3 cm) high × 7⅛" (18 cm)
diameter. Cross-shaped base: stone, 12⅝ × 21⅛" (32 × 53.6 cm).
X-shaped base: stone, 45⅝ × 18⅛" (116 × 46 cm). Musée National
d'Art Moderne, Atelier Brancusi, Centre Georges Pompidou, Paris*

16 Bird in Space, *1930. Polished bronze, height, 53⅛" (135 cm).
Base, height, 9" (22.8 cm). Peggy Guggenheim Collection, Venice*

17 Maiastra, *1910–12. Polished bronze, 21⅞ × 6¾ × 7"
(55.5 × 17 × 17.8 cm). Two bases: 1. stone, height, 13¾" (35 cm); 2.
relief with two stylized birds, 10¾ × 8⅝ × 6¾" (27.3 × 22 × 17 cm).
The Tate Gallery, London*

18 Maiastra, *1915. White marble, 24" (60.9 cm) high × 23" (58.4 cm)
circumference. Base: marble, 5⅞" (15 cm) high × 5" (12.7 cm)
diameter. Philadelphia Museum of Art. The Louise and Walter
Arensberg Collection. Photograph by Brancusi*

19 The Cock, *1935. Polished bronze, 40¾ × 8¼ × 4⅜"
(103.4 × 21 × 11 cm). Four-part base of limestone and oak, overall
height, 59" (150 cm). Musée National d'Art Moderne, Centre Georges
Pompidou, Paris*

20 The Cock, *1924. Walnut, height, 36⅛" (91.8 cm). Cylindrical
base: wood, height, 11⅜" (29 cm). The Museum of Modern Art, New
York*

21 The Newborn, *1920. Polished bronze, 5¾ × 8¼ × 5¾"
(14.6 × 21 × 14.6 cm). The Museum of Modern Art, New York. Lillie P.
Bliss Bequest*

22 The Newborn I, *1915. White marble, 5¾ × 8¼ × 5⅞"
(14.6 × 21 × 14.8 cm). Philadelphia Museum of Art. The Louise and
Walter Arensberg Collection*

23 Head of a Woman (Abstract Head), *1922. Marble, 11¼ × 7⅞ × 7⅛"
(28.5 × 20 × 18 cm), without base. Private collection*

24 Sleeping Muse I, *1910. Gilded bronze, 6¼ × 10⅝ × 7⅛"
(16 × 27 × 18 cm). Private collection*

25 Mademoiselle Pogany I, *1913. Polished bronze with black patina,
17¼ × 8½ × 12½" (43.8 × 21.5 × 31.7 cm). The Museum of Modern
Art, New York. Acquired through the Lillie P. Bliss Bequest*

26 Mademoiselle Pogany II, *1925. Plaster, 17¾ × 7½" (45 × 19 cm).
Musée National d'Art Moderne, Centre Georges Pompidou, Paris*

27 Mademoiselle Pogany III, *1933. Polished bronze, 17⅛ × 6⅝ × 9¼"
(45.3 × 16.8 × 23.5 cm). Musée National d'Art Moderne, Atelier
Brancusi, Centre Georges Pompidou, Paris*

28 Princess X, *1916. Polished bronze, 22¼ × 16½ × 9½"
(56.5 × 42 × 24 cm). Musée National d'Art Moderne, Atelier Brancusi,
Centre Georges Pompidou, Paris*

29 Beginning of the World, *1924. Polished bronze, 7½ × 11¼ × 6⅞"
(19 × 28.6 × 17.5 cm). Disk: polished steel, diameter, 17¾" (45 cm).
Base: wood, 29⅛ × 18⅞ × 15¾" (74 × 48 × 40 cm). Musée National
d'Art Moderne, Atelier Brancusi, Centre Georges Pompidou, Paris*

30 Torso of a Young Man I, *1922. Maple, 19 × 12⅜ × 7¼"
(48.3 × 31.5 × 18.5 cm). Philadelphia Museum of Art. The Louise and
Walter Arensberg Collection*

31 White Negress I, *1923. Veined marble, 15 × 5⅝ × 7"
(38.1 × 14.3 × 17.9 cm). Two-part marble base: overall height, 9¾"
(24.8 cm). Philadelphia Museum of Art. The Louise and Walter
Arensberg Collection*

32 Blond Negress I, *1926. Polished bronze, 15⅛ × 5½ × 7⅛"
(38.5 × 14 × 18 cm). Two bases: stone. Wilhelm Lehmbruck Museum,
Duisburg*

33 Little French Girl, *1914. Oak, 49 × 8¾ × 8½"
(124.5 × 22.2 × 21.6 cm). Solomon R. Guggenheim Museum, New
York. Gift, Estate of Katherine S. Dreier*

34 Chimera, *1915. Oak, 60¼ × 8⅝ × 9½" (153 × 21.9 × 24.1 cm). Philadelphia Museum of Art. The Louise and Walter Arensberg Collection*

35 Adam and Eve, *1921. Chestnut (Adam) and oak (Eve), 89⅜ × 19 × 17⅜" (227 × 48.2 × 44 cm). Limestone block: height, 5⅜" (13.5 cm). The Solomon R. Guggenheim Museum, New York*

36 Socrates, *1922. Oak, 43¾ × 11⅜ × 14½" (111 × 28.8 × 36.8 cm). Limestone cylinder: height, 7" (17.8 cm). The Museum of Modern Art, New York. Mrs. Simon Guggenheim Fund*

37 The Sorceress, *1916. Maple, 39⅜ × 22 × 26¾" (100 × 56 × 68 cm). Bases: stone, wood. The Solomon R. Guggenheim Museum, New York*

38 Fish, *1922. Yellow marble, 5 × 16⅞ × 1⅛" (12.7 × 42.8 × 3 cm). Two-part base of mirror and oak, overall height, 24⅛" (61.3 cm). Philadelphia Museum of Art. The Louise and Walter Arensberg Collection*

39 Fish, *1930. Blue-gray marble, 21⅛ × 71 × 5⅛" (53.7 × 180.3 × 13 cm). Three-part base of white marble, ball bearings, and limestone (cut by A. Istrati in 1948), overall height, 29⅛" (74 cm). The Museum of Modern Art, New York. Acquired through the Lillie P. Bliss Bequest*

40 The Seal II, *1943. Blue-gray marble, 44⅛ × 39⅜ × 33⅛" (112 × 100 × 84 cm). Two bases: stone, 1. height, 11⅜" (29 cm); 2. height, 9⅞" (25 cm). Musée National d'Art Moderne, Centre Georges Pompidou, Paris*

41 The Miracle (The Seal I), *1936? White marble, 42¾ × 44⅞ × 13" (108.6 × 114 × 33 cm). Two bases: stone, 1. height, 11⅜" (29 cm); 2. height, 9⅞" (25 cm). The Solomon R. Guggenheim Museum, New York*

42 The Flying Turtle (The Turtle), *1943. Marble, 12½ × 36⅝ × 27⅛" (31.8 × 93 × 69 cm). Base: diameter, 17¾" (45 cm). The Solomon R. Guggenheim Museum, New York*

43 Three Penguins, *1912. Marble, 22¼ × 20¾ × 13½" (56.5 × 52.8 × 34.3 cm). Philadelphia Museum of Art. The Louise and Walter Arensberg Collection*

44, 45, 46 Gate of the Kiss, *1937–38. Tîrgu Jiu*

47 Table of Silence, *1937–38. Tîrgu Jiu*

48, 49, 50 Endless Column, *1937–38. Tîrgu Jiu*

51 *Self-portrait photograph of the artist in his studio, c. 1933–34. Behind Brancusi,* Fish; *to his left,* Leda

52 *Photograph of the studio in Bucharest, c. 1901. Two versions of* Écorché *and, left, a cast of the classical* Antinous *from which Brancusi drew his inspiration. Photograph by Brancusi*

53 *Photograph of the studio on the Impasse Ronsin, c. 1945–46. Four Grand Coqs and, in the foreground,* King of Kings. *Photograph by Brancusi*

54 *Endless Column, 1937–38. Photograph by Brancusi*

55 *Exterior of the artist's studio*

56 *Reconstruction of Brancusi's studio, at the Musée National d'Art Moderne, Centre Georges Pompidou, Paris*

57 *Brancusi's studio, c. 1925. At the center:* Bird in Space, Column of the Kiss, The Cock, *and* Torso of a Girl. *Photograph by Brancusi*

58 Bird in Space *in the studio, 1925. White marble, 71" (180.2 cm) high × 18½" (47 cm) max. circumference. Cylindrical base: stone, 6¾" (17 cm) high × 6¼" (15.8 cm) diameter. National Gallery of Art, Washington, D.C. Gift of Eugene and Agnes E. Meyer. Photograph by Brancusi*

Selected Bibliography

Bach, Friedrich Teja, Margit Rowell, and Ann Temkin. *Constantin Brancusi, 1876–1957*. Philadelphia: Philadelphia Museum of Art, 1995.

Dumitresco, Natalia, Pontus Hulten, and Alexandre Istrati. *Brancusi*. Paris: Flammarion, 1986.

Eliade, Mircea. "Brancusi et les mythologies." In *Témoignages sur Brancusi*. Paris: Arted, 1967.

Geist, Sydney. *Brancusi. The Sculpture and Drawings*. New York: Harry N. Abrams, 1975.

———. *Brancusi. A Study of the Sculpture*. New York: Grossman, 1968.

Giedion-Welcker, Carola. *Constantin Brancusi*. Neuchâtel: Le Griffon, 1959.

Jianou, Ionel. *Brancusi*. Paris: Arted, 1963.

Miller, Sandra. *Constantin Brancusi. A Survey of His Work*. Oxford: Clarendon Press, 1995.

Pound, Ezra. "Brancusi." *The Little Review* (New York), Autumn 1921, pp. 3–7.

Ray, Man. *Autoportrait*. Paris: Robert Laffont, 1964.

Series Coordinator, English-language edition: Ellen Rosefsky Cohen
Editor, English-language edition: Nola Butler
Designer, English-language edition: Judith Michael

Library of Congress Catalog Card Number: 97–70935
ISBN 0–8109–4693–9

Copyright © 1997 Ediciones Polígrafa, S.A.
Reproductions copyright © ADAGP for the works and photographs of Brancusi
English translation copyright © 1997 Harry N. Abrams, Inc.

Printed and bound in Spain by Filabo, S.A.
Sant Joan Despí (Barcelona)
Dep. Leg.: B. 12.302 – 1997